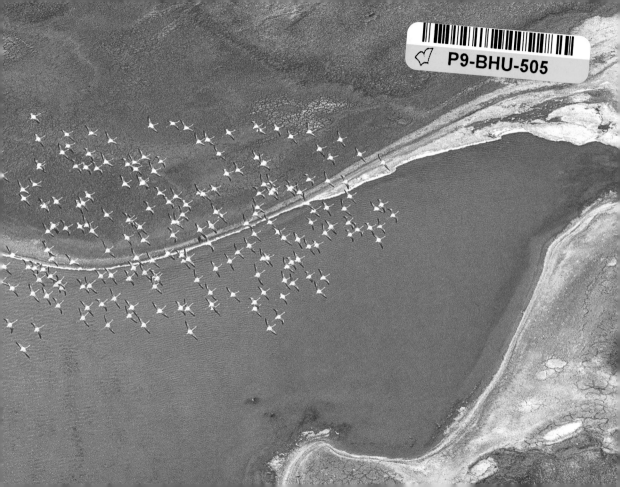

WILDLIFE OF AFRICA

GERALD HOBERMAN

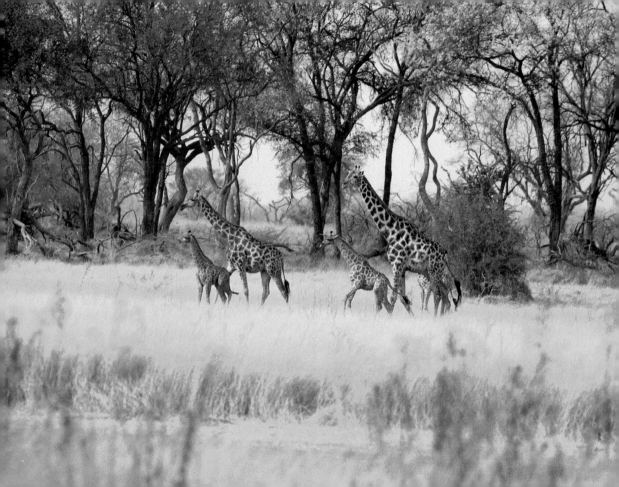

ROYAL MALEWANE

Central Reservations:
Tel: +27 15 793 0150 Fax: +27 15 793 2879
Email: info@royalmalewane.com

WILDLIFE OF AFRICA

GERALD HOBERMAN

PHOTOGRAPHS IN CELEBRATION OF THE CONTINENT'S
EXTRAORDINARY BIODIVERSITY, FAUNA AND FLORA

THE GERALD & MARC HOBERMAN COLLECTION
CAPE TOWN • LONDON • NEW YORK

Dedicated to Noah Michael Bard

CONTENTS

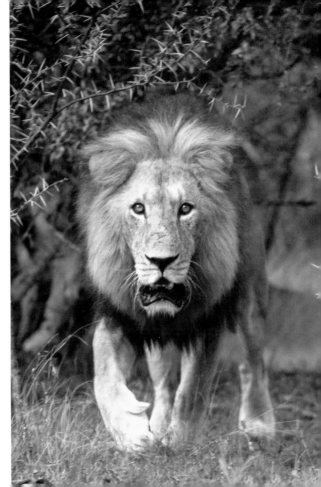

Concept, photography, design and production control: Gerald & Marc Hoberman
Reproduction: Marc Hoberman
Editor: Roelien Theron
Layout: Christian Jaggers

www.hobermancollection.com

ISBN 1-919939-23-7
ISBN 978-191993923-0

Wildlife of Africa is published by The Gerald & Marc Hoberman Collection (Pty) Ltd
Reg. No. 99/00167/07, PO Box 60044, Victoria Junction, 8005, Cape Town, South Africa
Telephone: 27-21-419 6657/419 2210 Fax: 27-21-425 4410
e-mail: office@hobermancollection.com

*For copies of this book or our larger coffee table edition printed with your company's logo
and corporate message, contact The Gerald & Marc Hoberman Collection.*

International marketing, corporate sales and picture library

ACKNOWLEDGEMENTS

The preparation necessary in producing this particular book has been complex, multidisciplined, challenging, sometimes arduous, but for all those people involved with it very exciting!

I am most fortunate to have developed very valuable relationships with the people who have assisted in the production of this book. I refer to them all with much appreciation and affection as the 'A team'. Without them, this volume could not have existed in its present form.

I also want to thank those people listed below who have contributed to the project.

Tony and Dee Adams
Alpheus
Randy Borman
Tony Brinkman
Bee Brummer
Sean and Ann Bryan
Marius Burger
Margie Cochran
Ken Cole
Charles Dickson
Dr AS Dippenaar
NR Durn
Max and Cecile Elstein
David Falconer
Arlene Fanaroff
Mel Goott
Randy Green

Robin and Berta Halse
Maureen Hargraves
Ted Harrison
Peter Herbert
Koti and Hanlie Herholdt
Lex Hess
Doris Jacobs
Karel Keinman
Brian Kirsch
Henri Kruger
Klaas Kruiper
Pat Lampi
Elias LeRiche
Peter le Roux
Miriam Meltzer
Renius Mhlongo
Nico Myburgh

Richard Randall
David Rattray
Harold Sack
Sammy L. Seawell
Malaki Sithole
Arnold Swart
Michael Terry
Chris van der Linde
Joseph van Os
John Visser
John Wakefield
Sharon Walleen
Jenny Walters
Frank and Brenda Watts
Daniel and Thorya Wheedon

INTRODUCTION

I have seen wondrous things. I have visited the rarest spots on earth in pursuit of my vision, for I dreamed of building up – and sharing with the world – a collection of indelible images of wildlife, each one thought-provoking, enduring and magical.

In the course of this odyssey I discovered majesty in mountains, companionship in people and a deep need to celebrate nature. The wealth of the vast outdoors and its extraordinary animal kingdom and their continuity over aeons, seem to me to represent our connection with infinity. It is a profoundly spiritual experience to stand in silent awe of creation, contemplating both our humble insignificance as human beings, and our triumphs.

The purity of early morning air has intoxicated my spirit, as has the smell of dust as rain begins to fall on Africa. I have been exhilarated by journeys in every kind of transport, from hot air balloon to helicopter, sea plane and mokoro.

I have marvelled at the sound of silence, revelled in remoteness, peace and tranquillity – and learned to fear them too.

On my journeys I have had several narrow escapes, and have only the grace of God to thank that I am here to tell the tale.

On the many field trips over the years, I have had the joy of family and friends accompanying me, which has brought rich quality time into all our lives.

With this collection, I bring you, with great delight, the very best of my wildlife photography. I have included examples of spectacular landscapes, marine mammals, birds and the night sky, for they are all part of the wildlife experience in Africa. I hope that these photographs will encourage more people to feel connected with and do their best to promote and conserve the fast-dwindling natural habitats of the world's diverse fauna and to protect its flora.

It is imperative that this bounteous heritage, subjected to myriad pressures, be preserved for future generations.

Gerald Hoberman

GERALD HOBERMAN

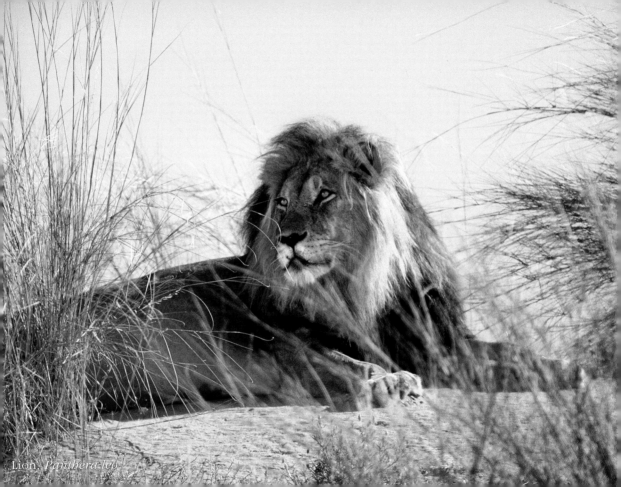
Lion *Panthera leo*

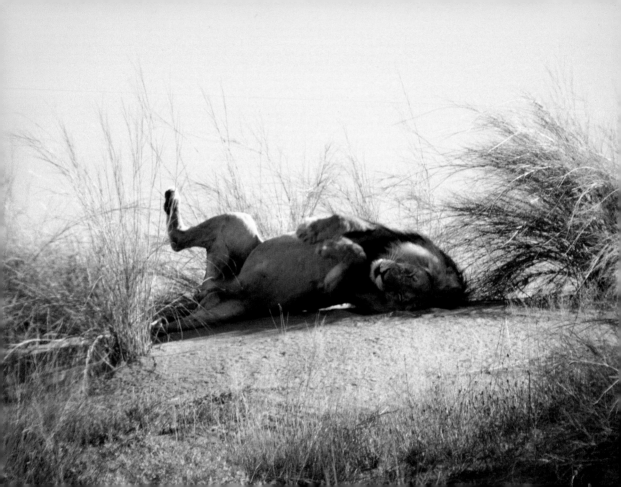

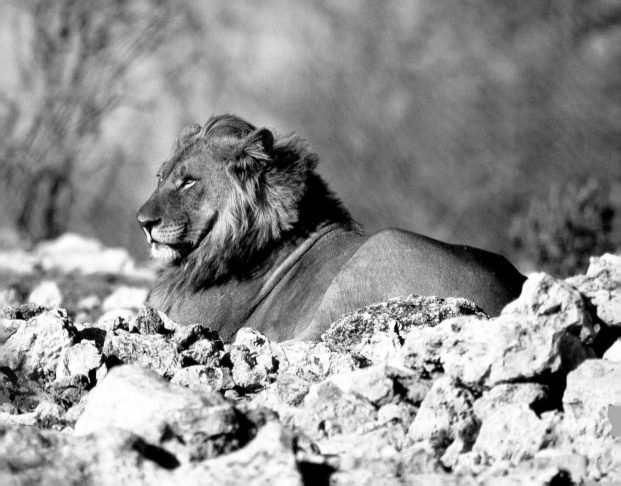

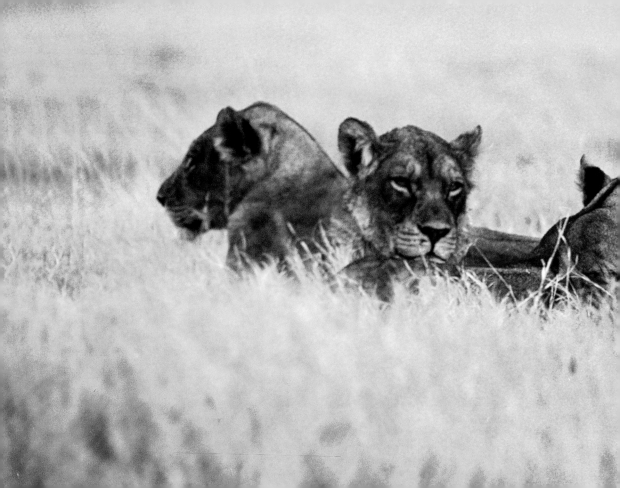

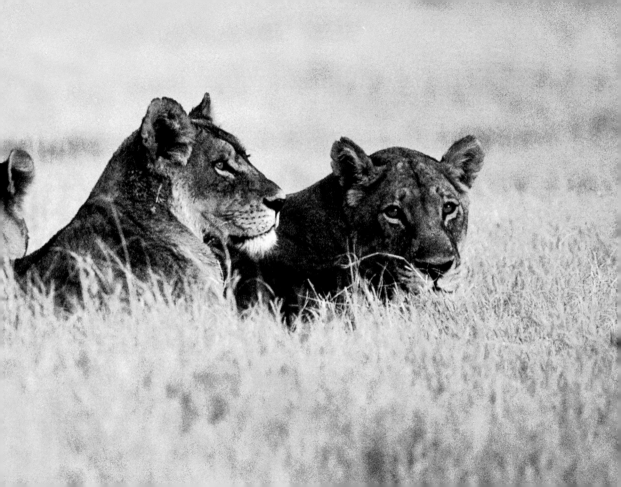

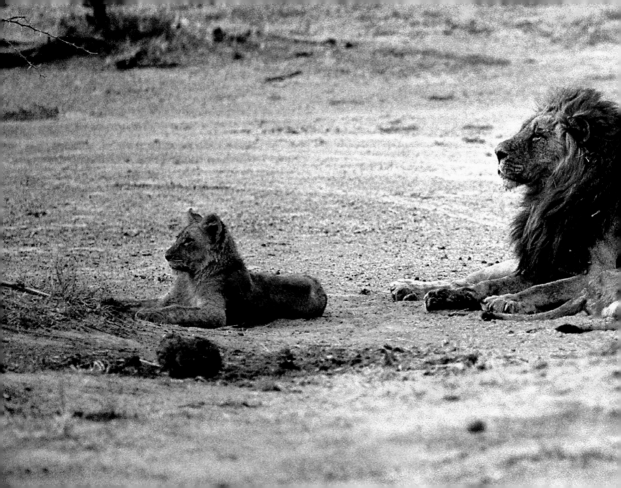

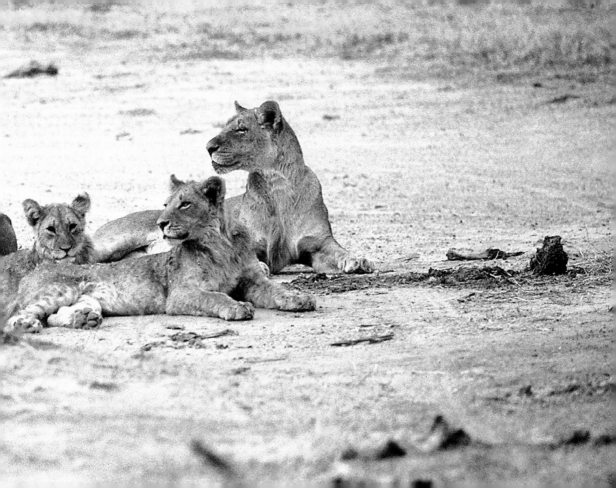

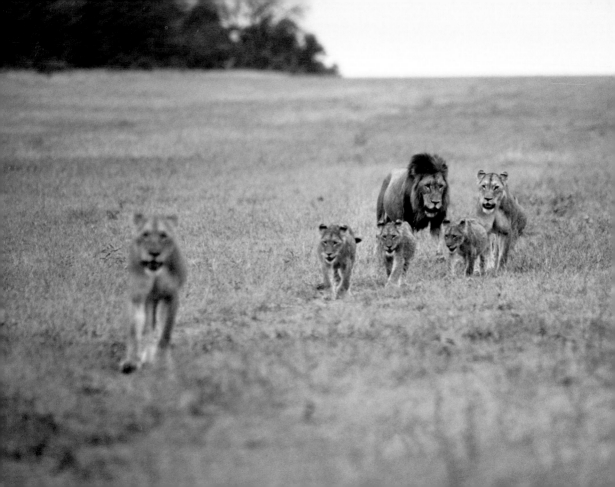

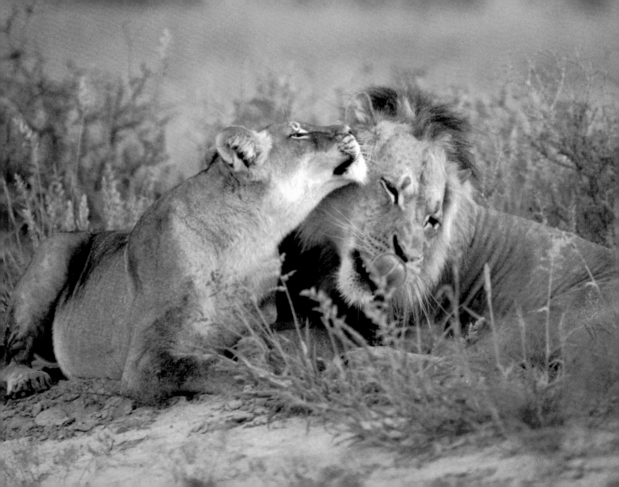

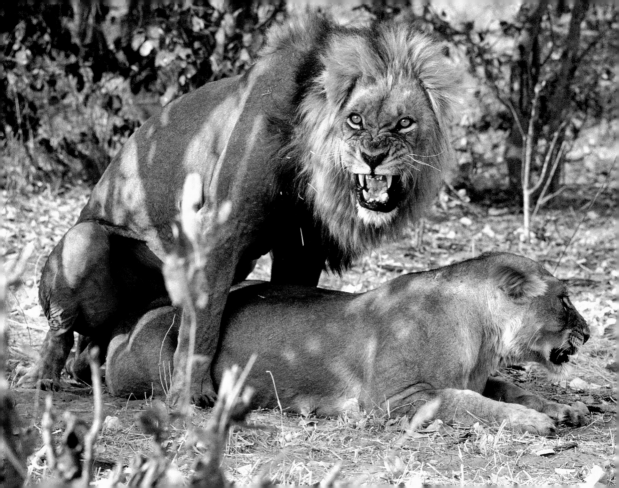

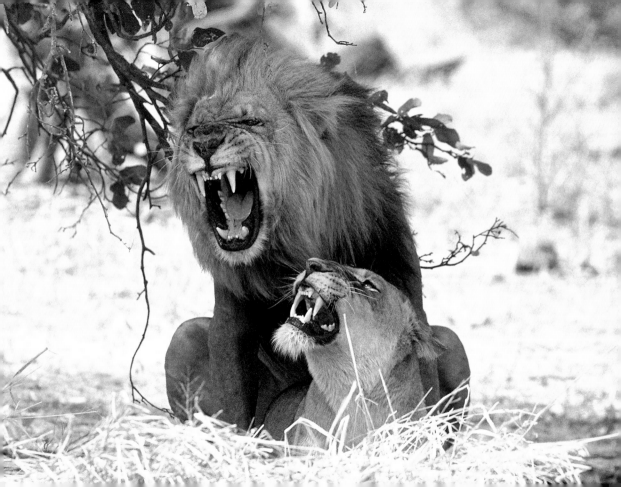

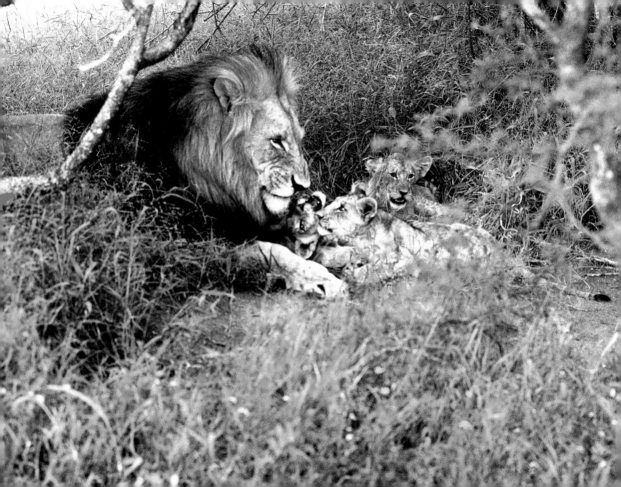

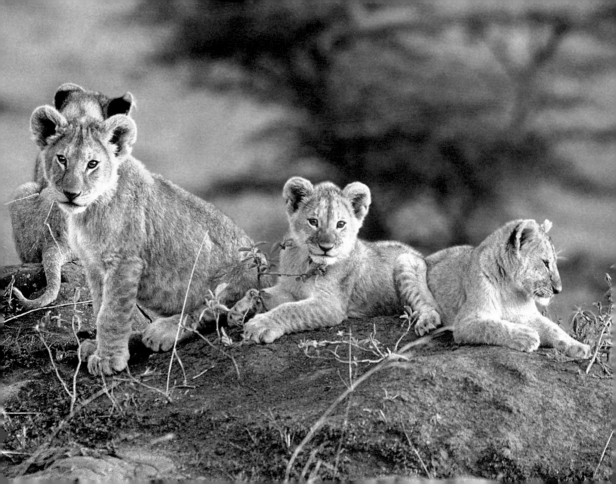

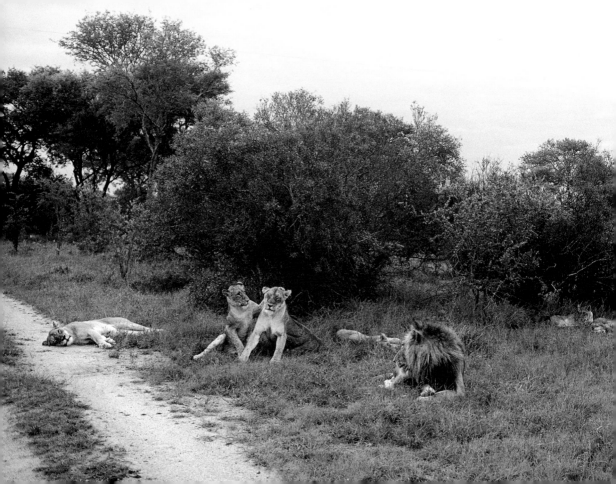

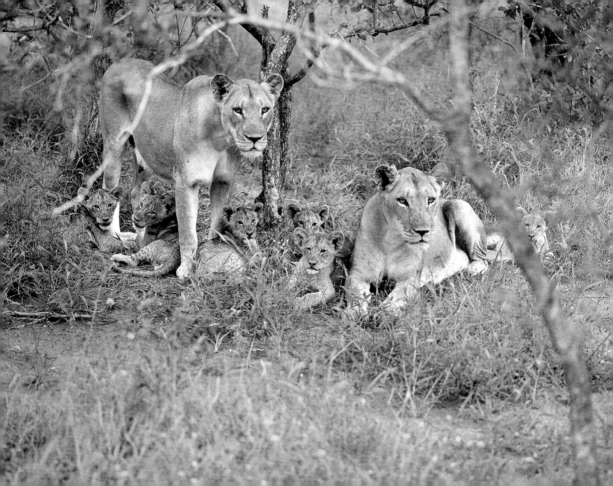

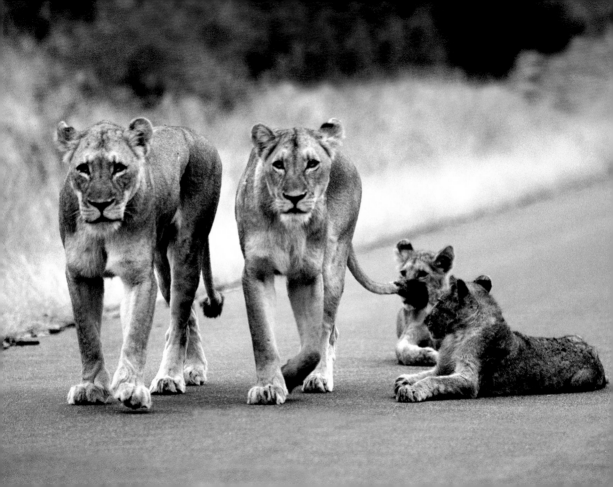

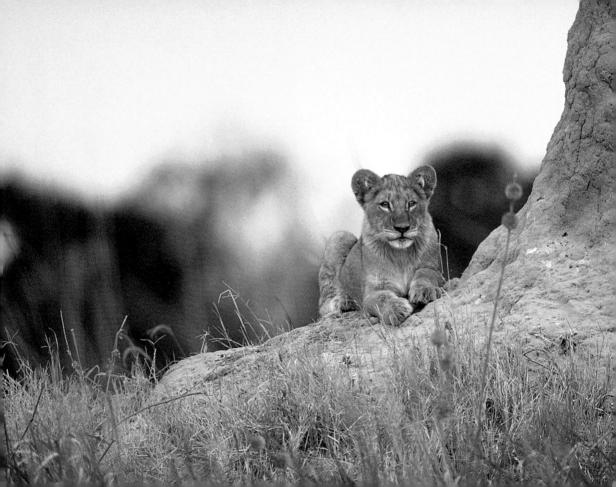

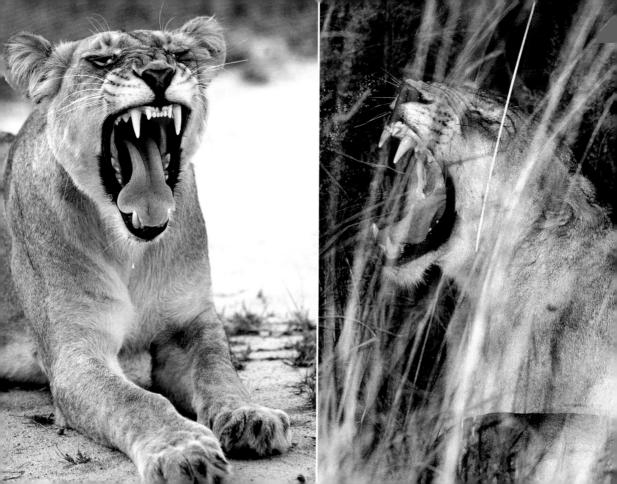

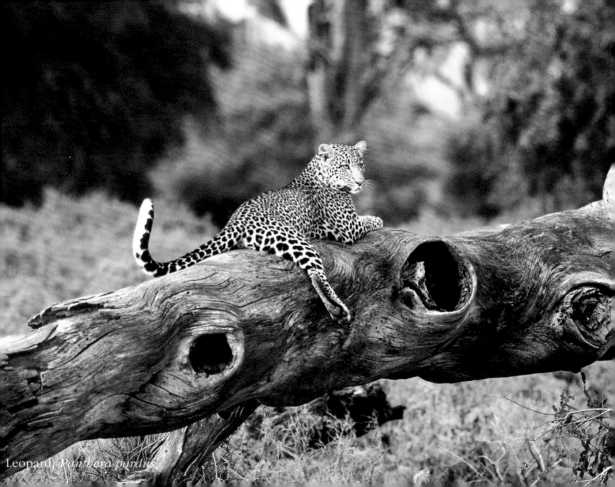

Leopard *Panthera pardus*

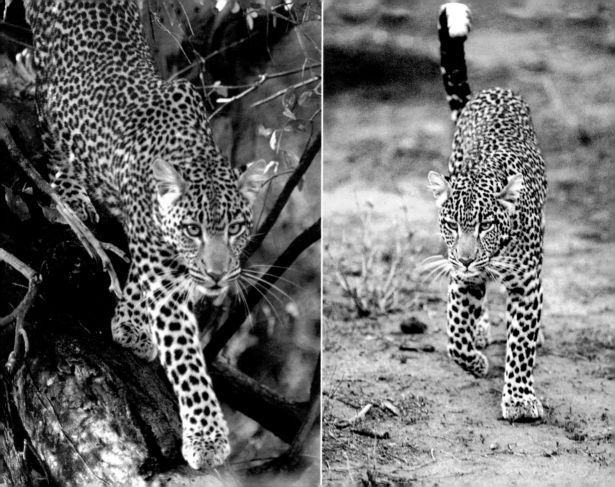

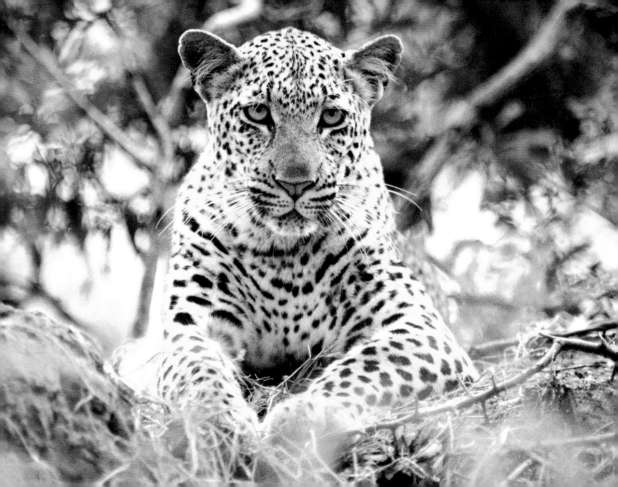

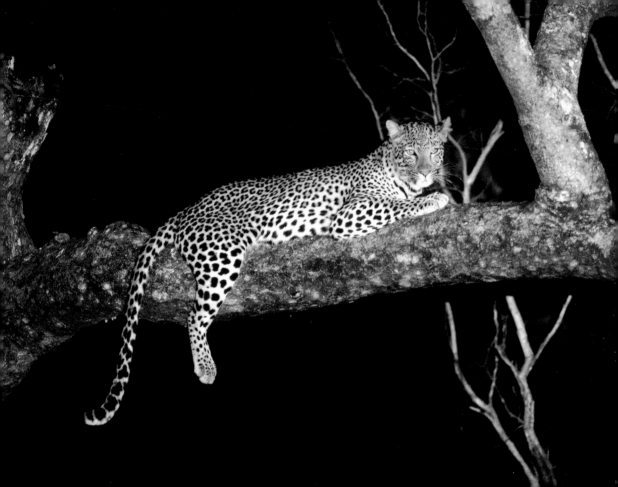

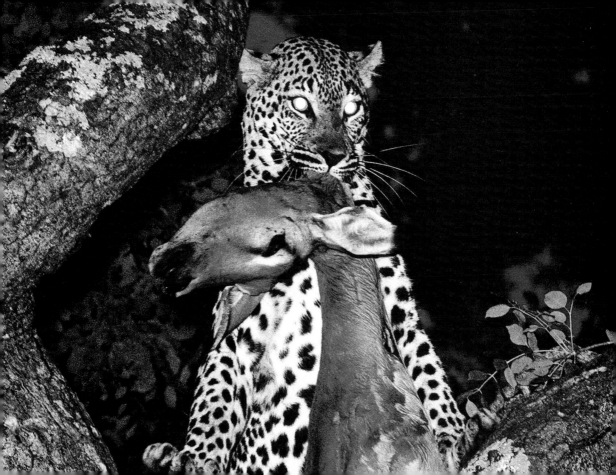

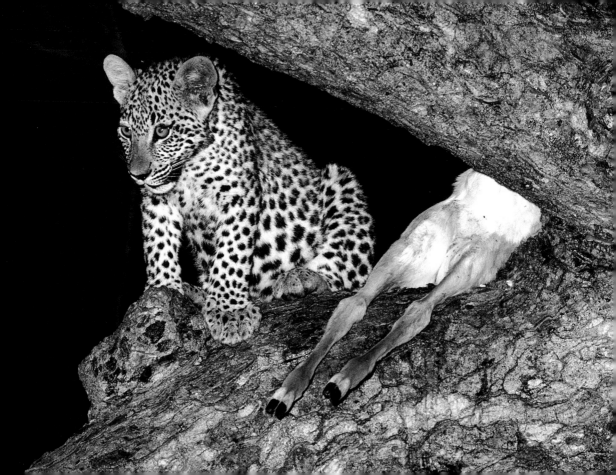

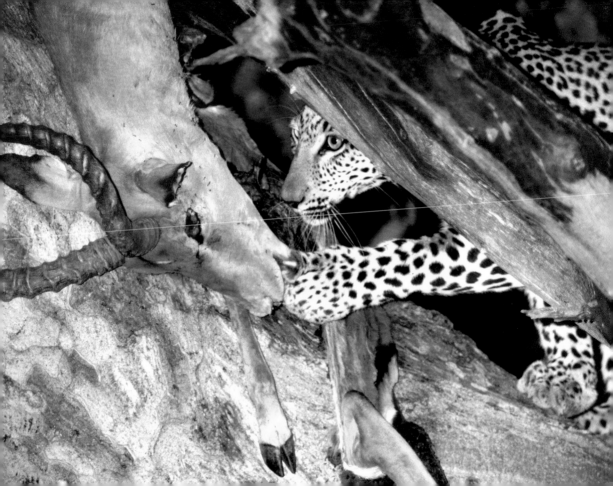

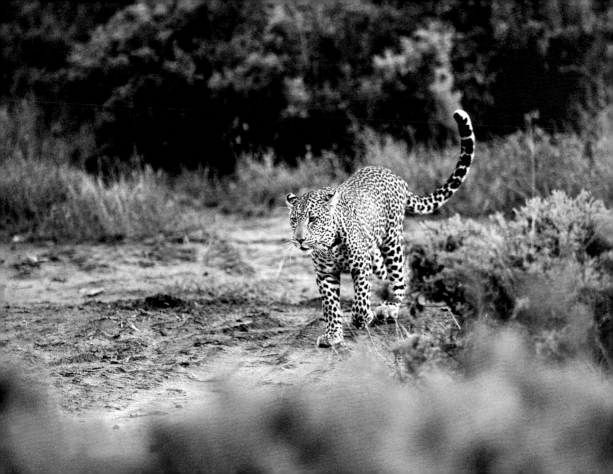

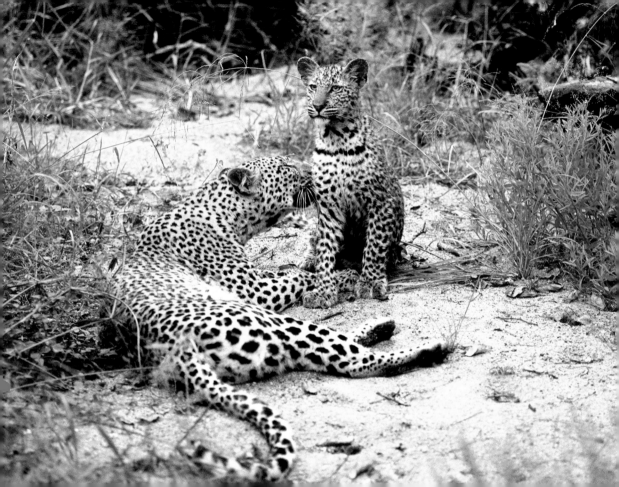

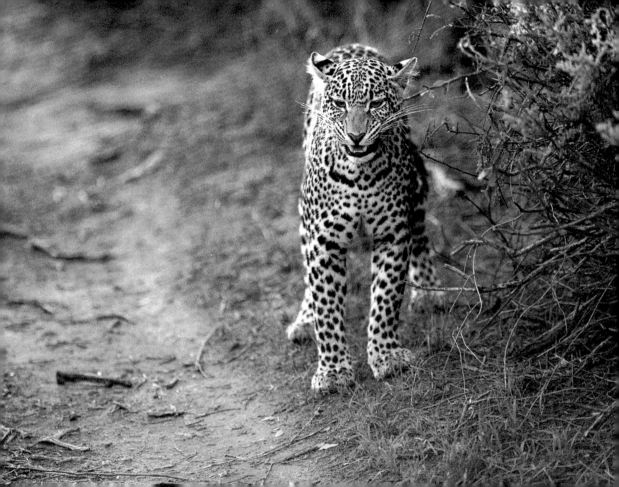

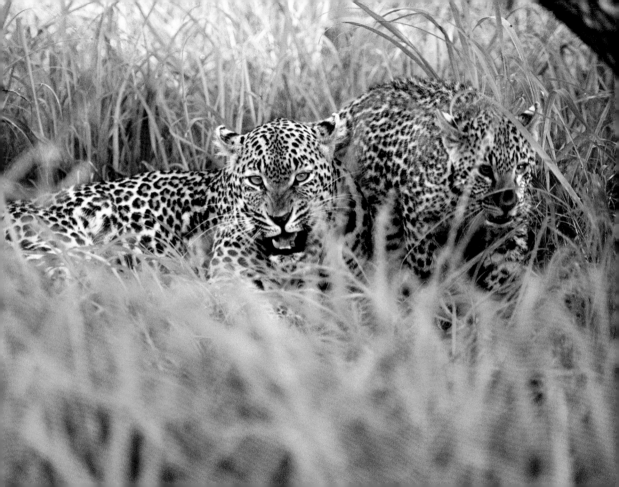

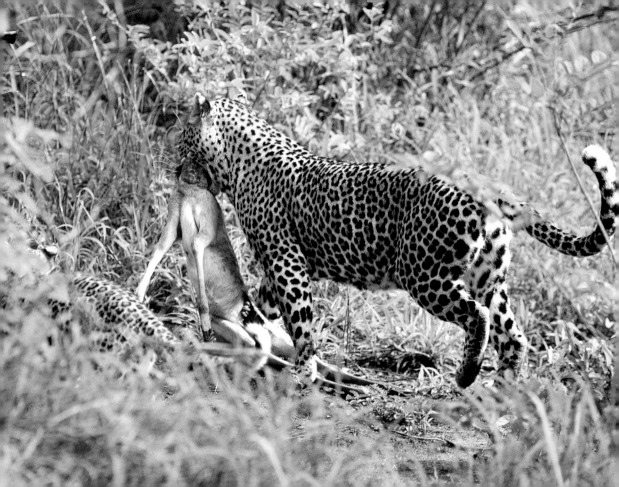

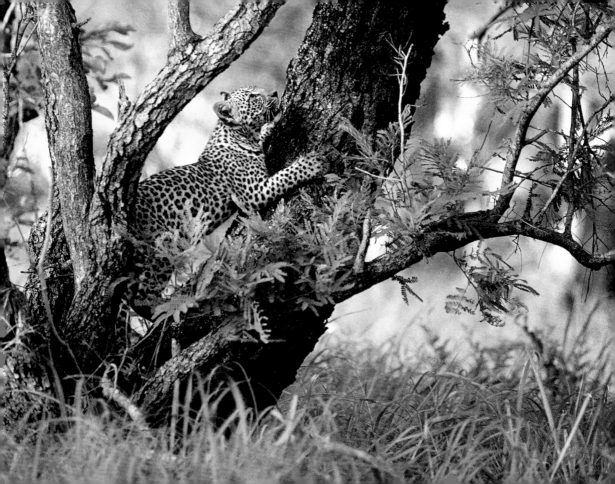

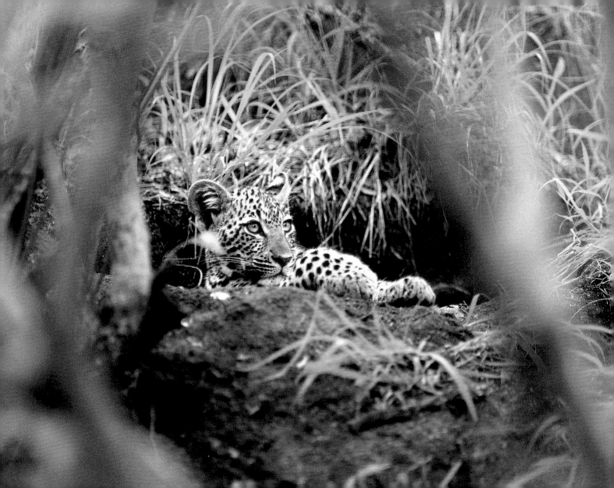

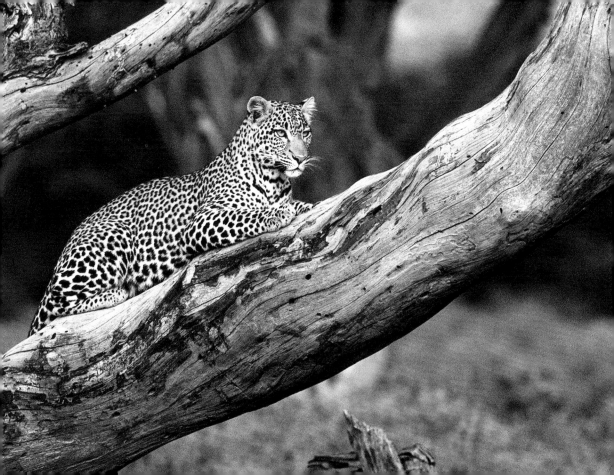

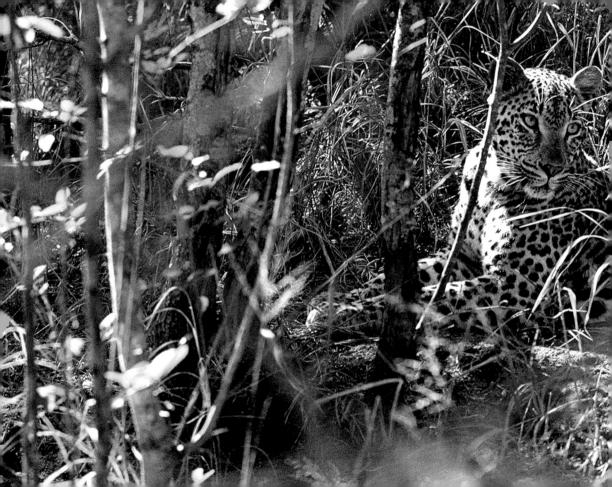

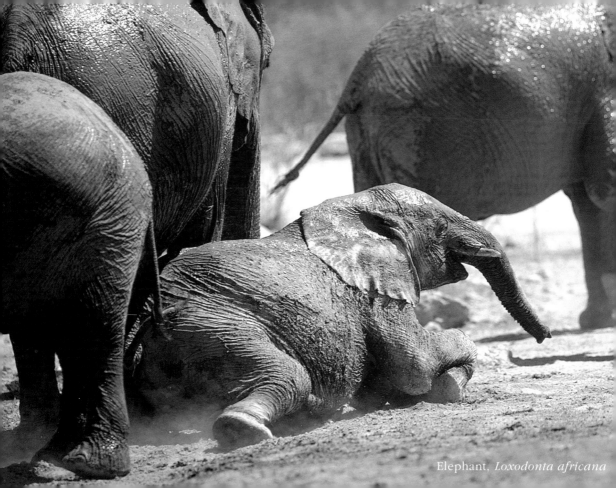

Elephant, *Loxodonta africana*

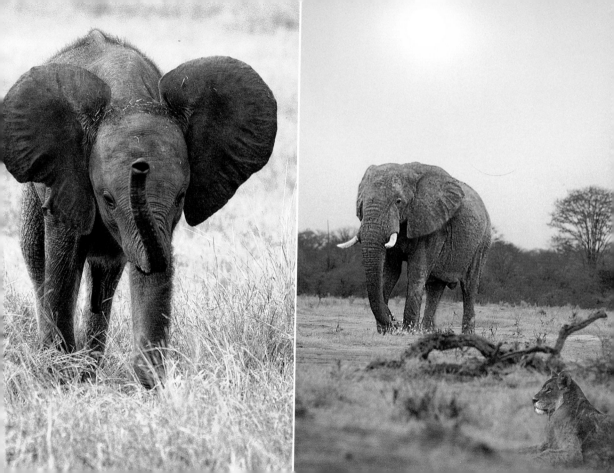

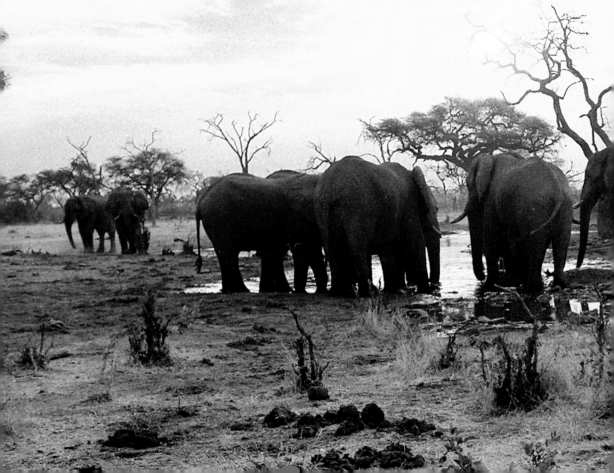

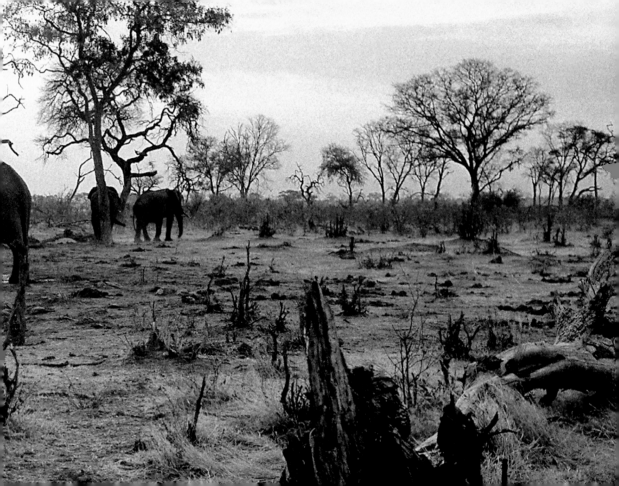

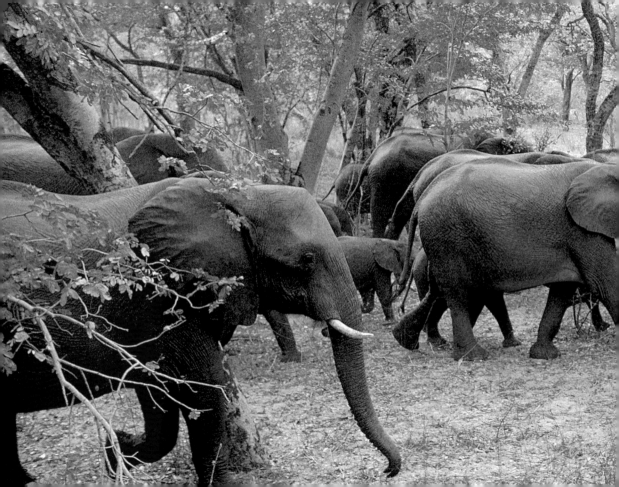

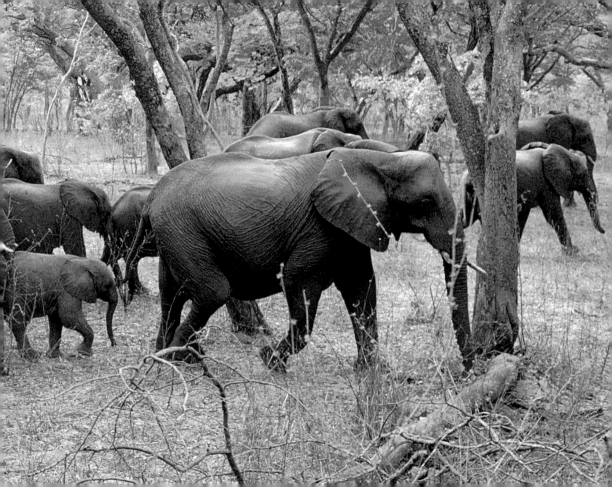

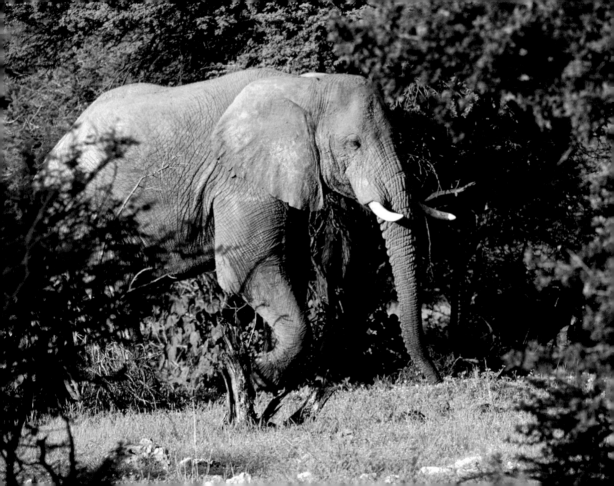

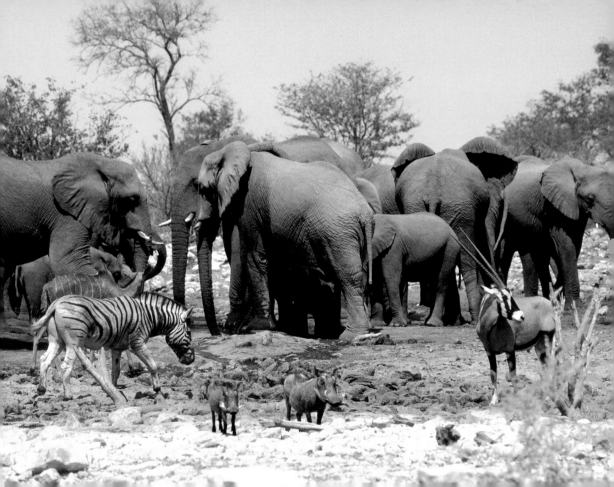

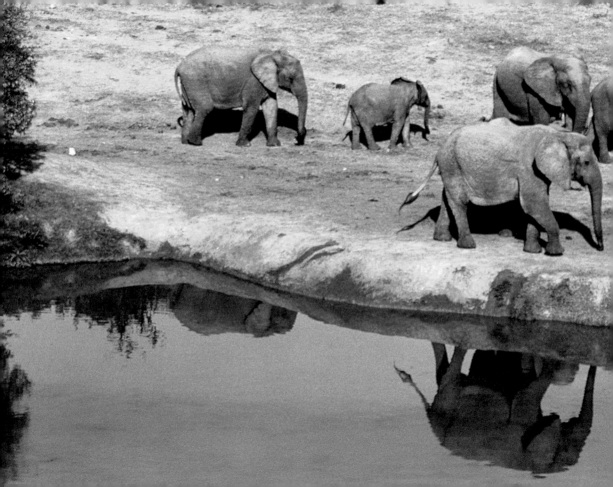

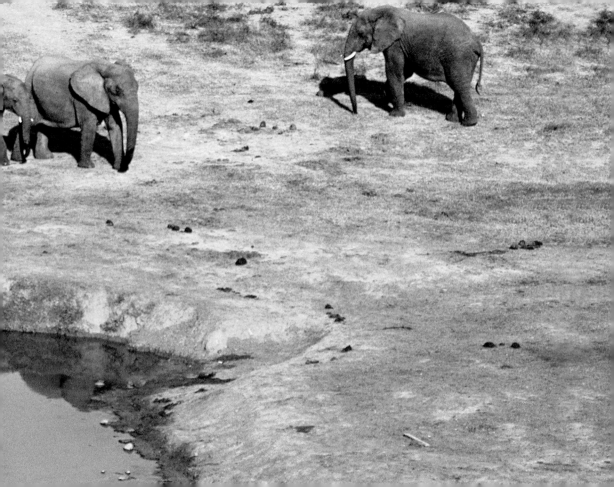

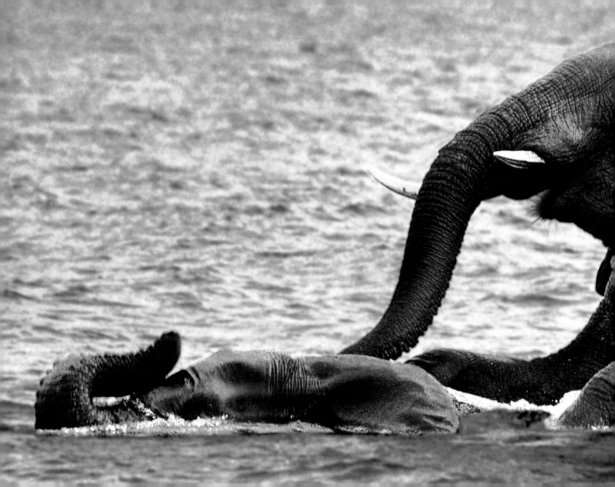

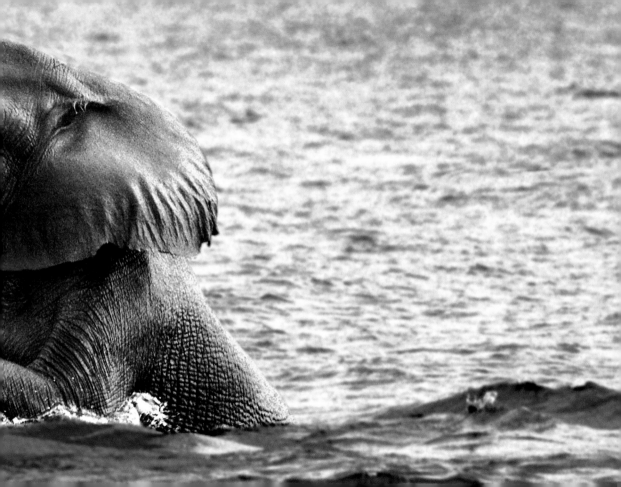

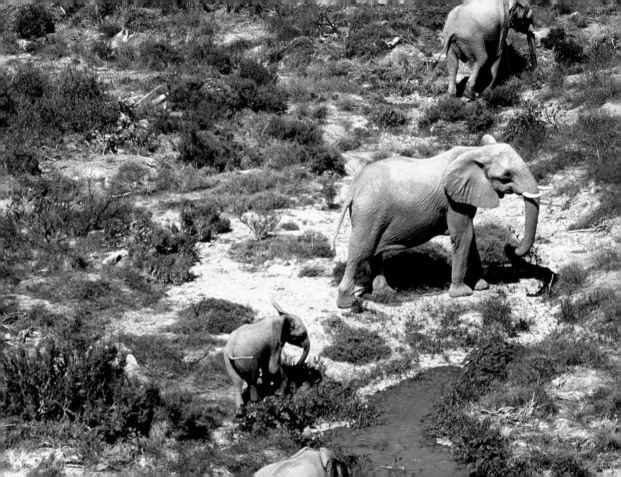

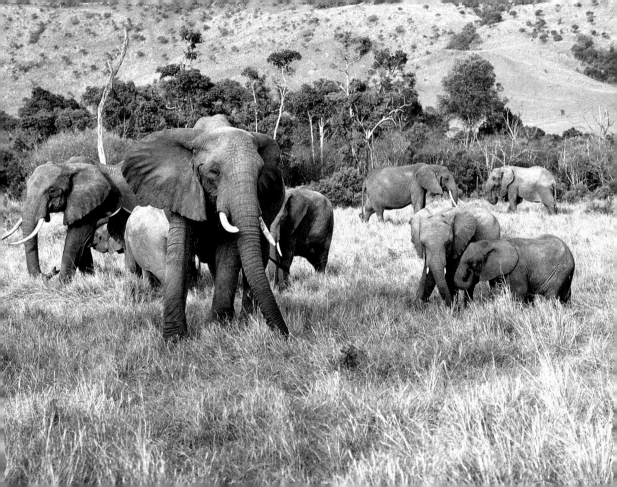

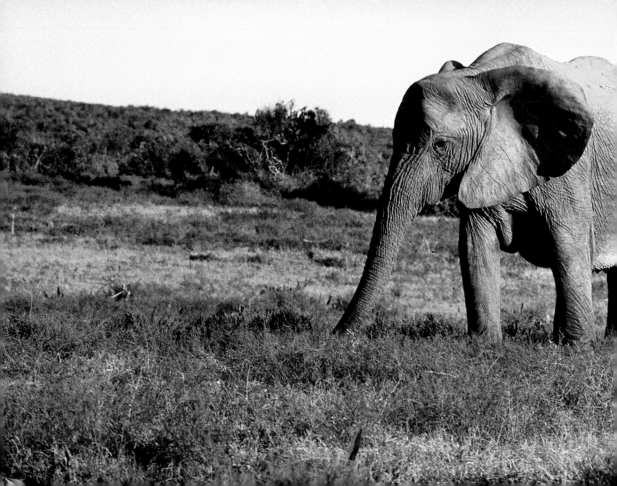

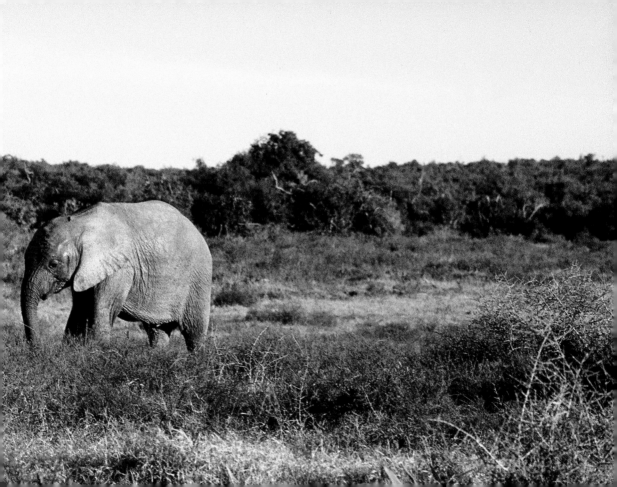

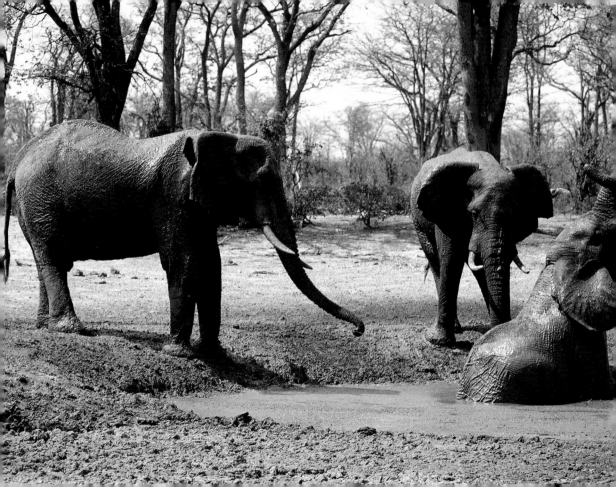

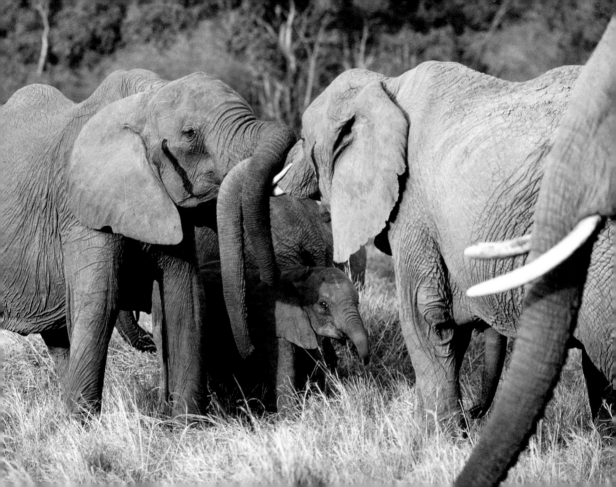

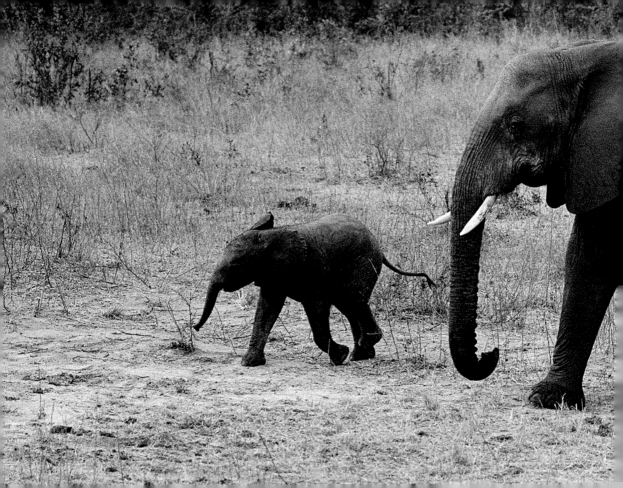

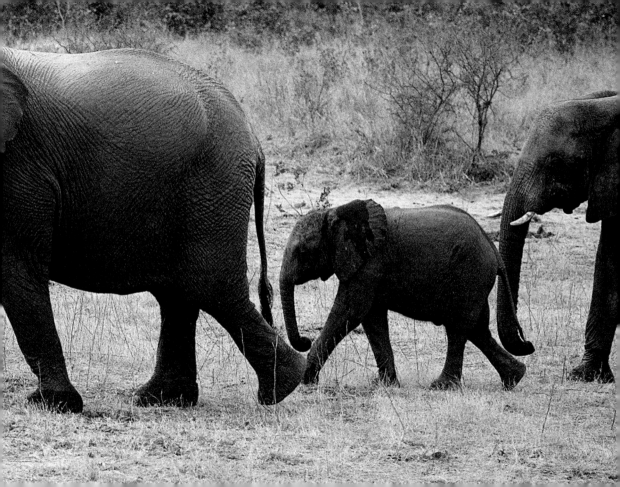

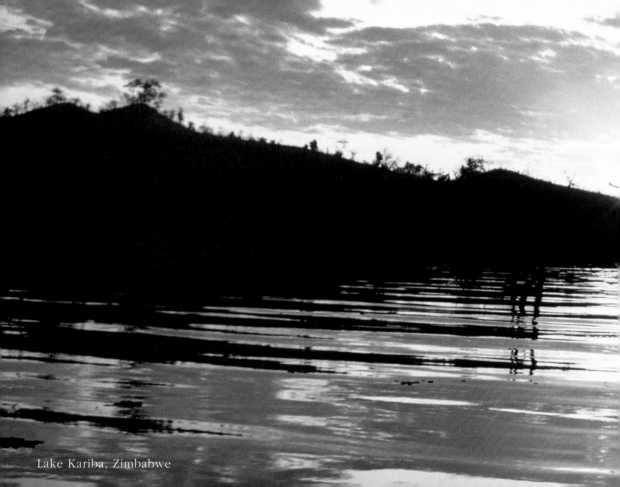
Lake Kariba, Zimbabwe

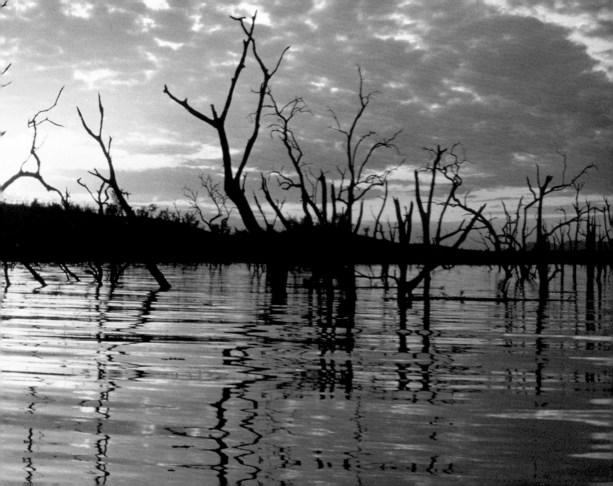

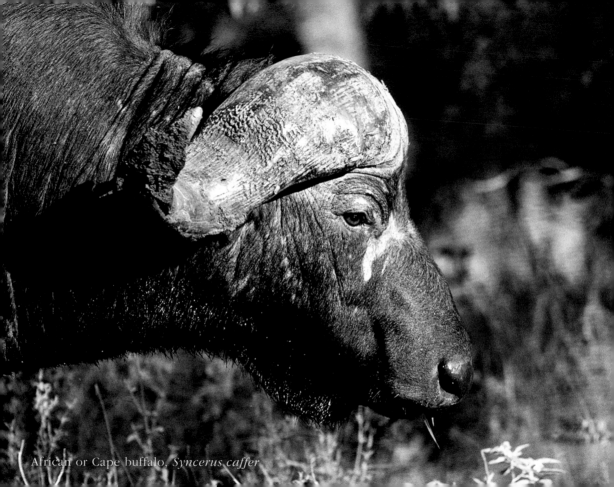

African or Cape buffalo, *Syncerus caffer*

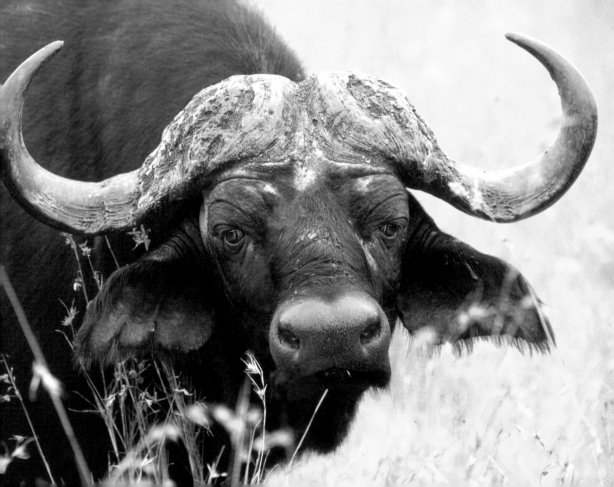

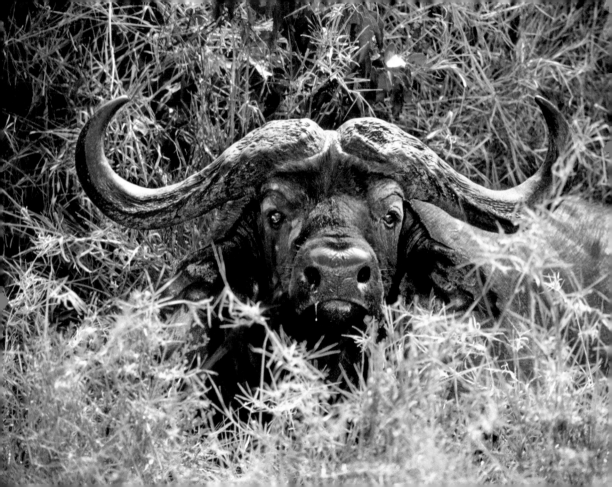

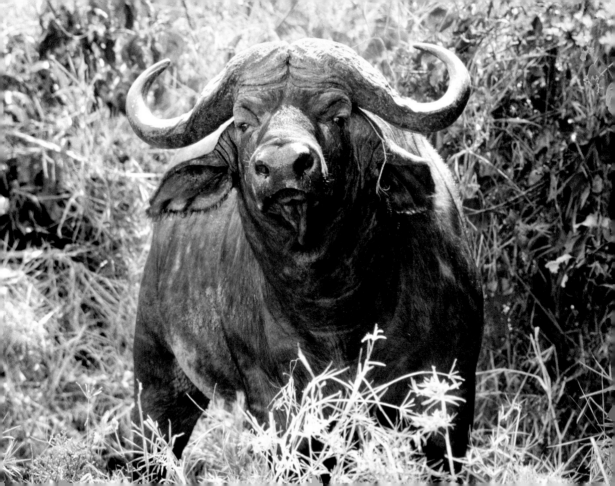

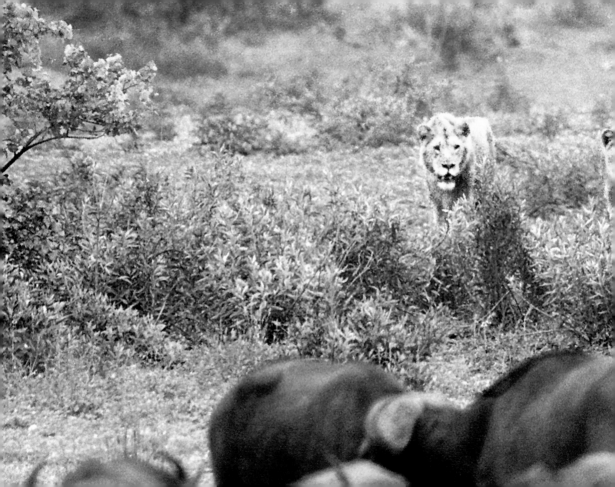

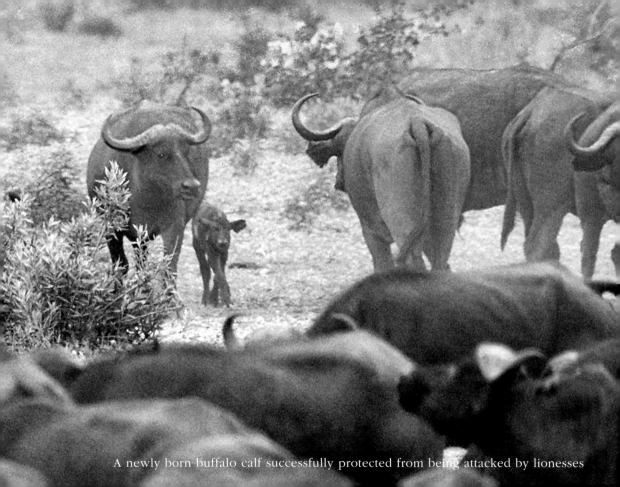

A newly born buffalo calf successfully protected from being attacked by lionesses

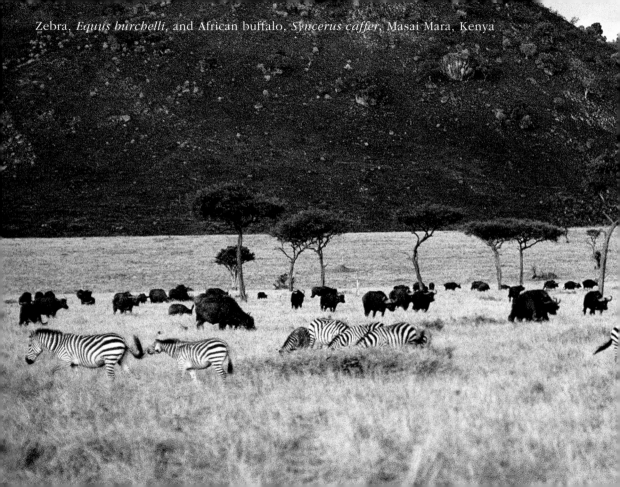
Zebra, *Equus burchelli*, and African buffalo, *Syncerus caffer*, Masai Mara, Kenya

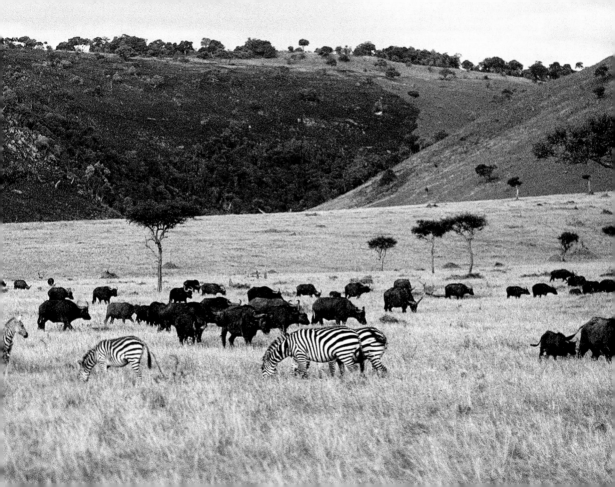

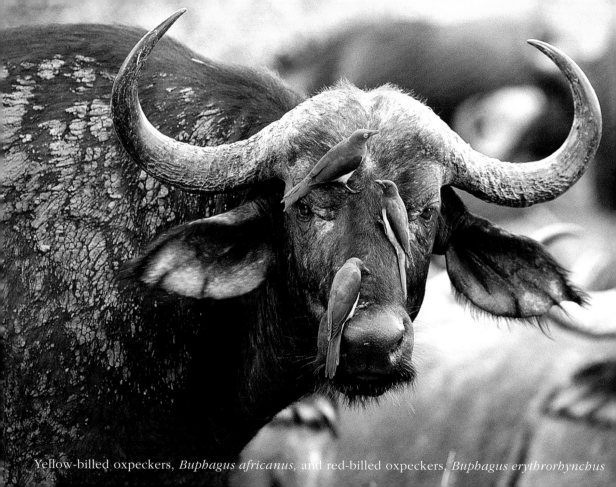

Yellow-billed oxpeckers, *Buphagus africanus*, and red-billed oxpeckers, *Buphagus erythrorhynchus*

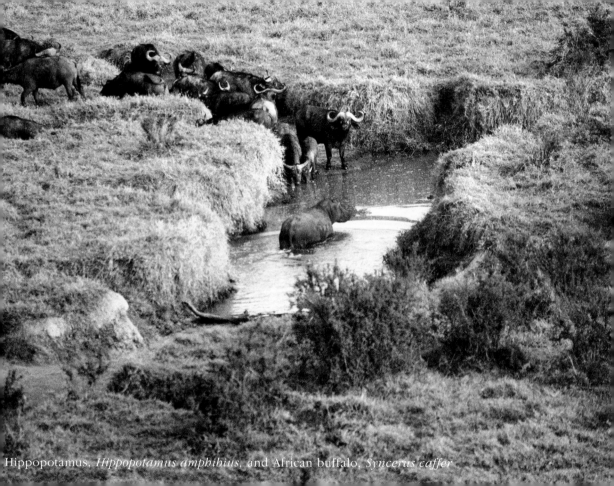

Hippopotamus, *Hippopotamus amphibius*, and African buffalo, *Syncerus caffer*

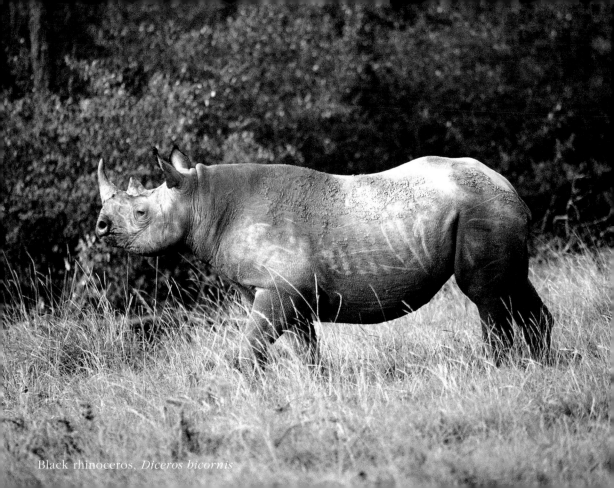
Black rhinoceros, *Diceros bicornis*

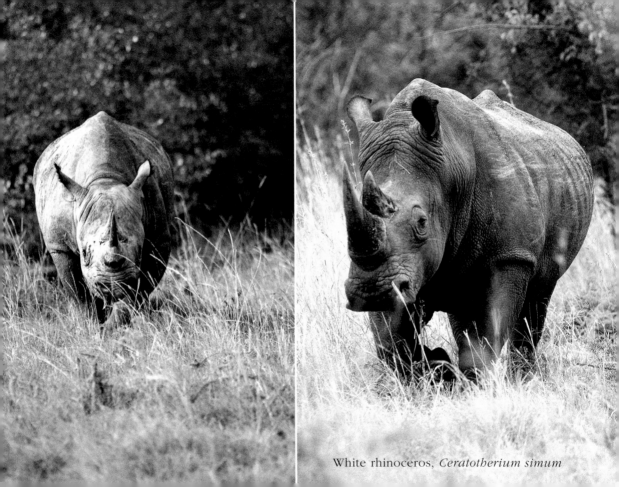
White rhinoceros, *Ceratotherium simum*

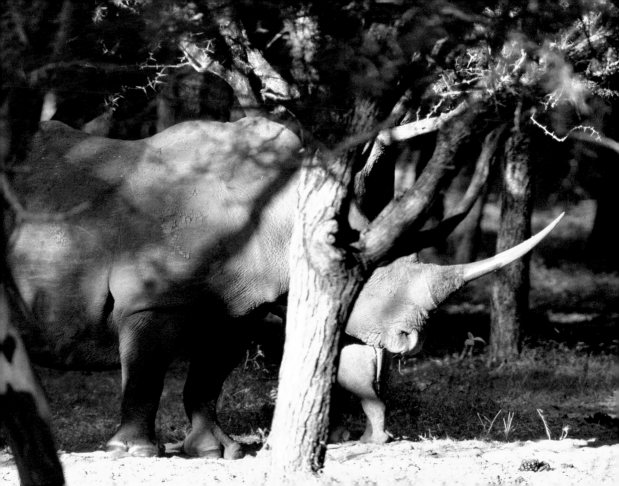

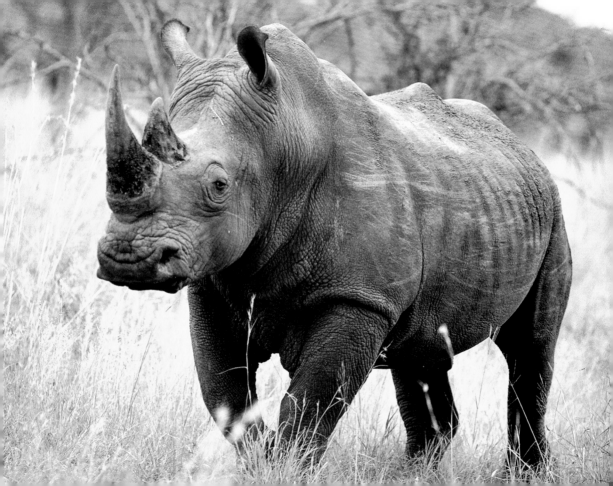

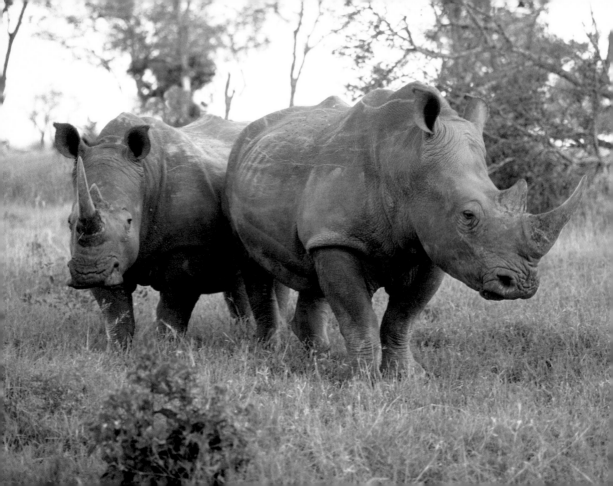

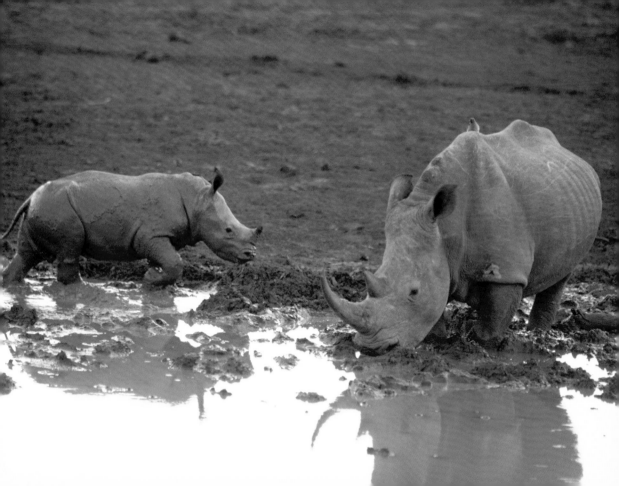

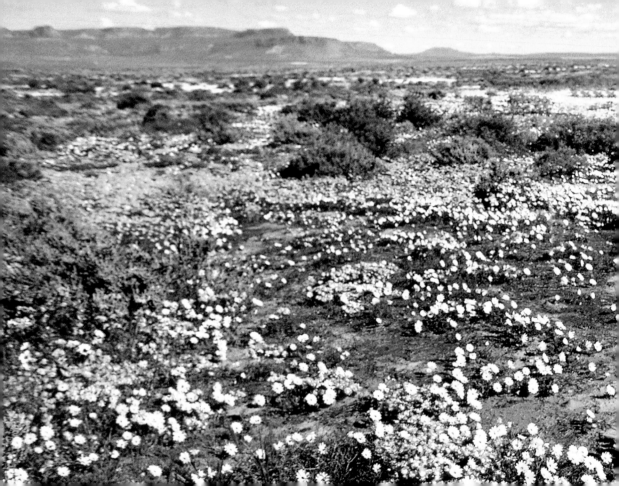

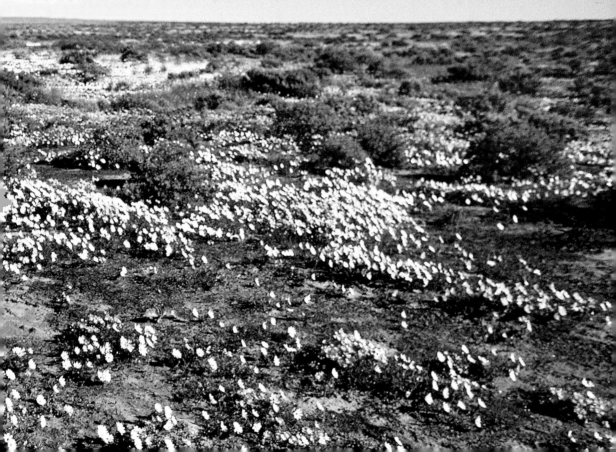

Wild flowers in spring, Namaqualand, South Africa

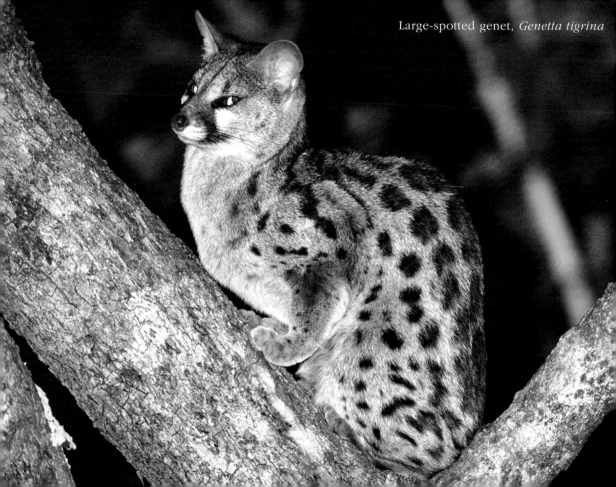

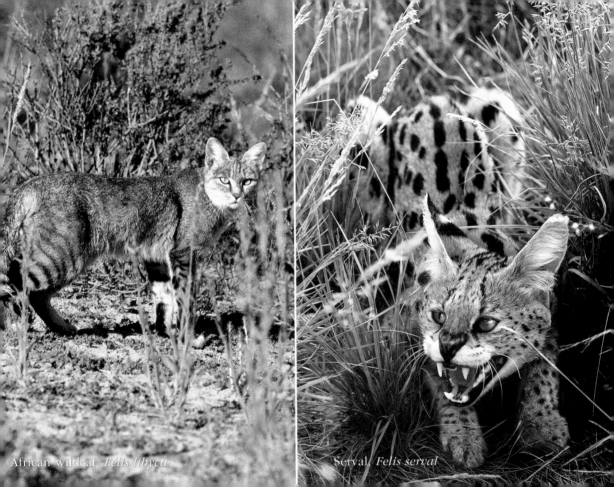

African wildcat, *Felis libyca*

Serval, *Felis serval*

Caracal *Felis caracal*

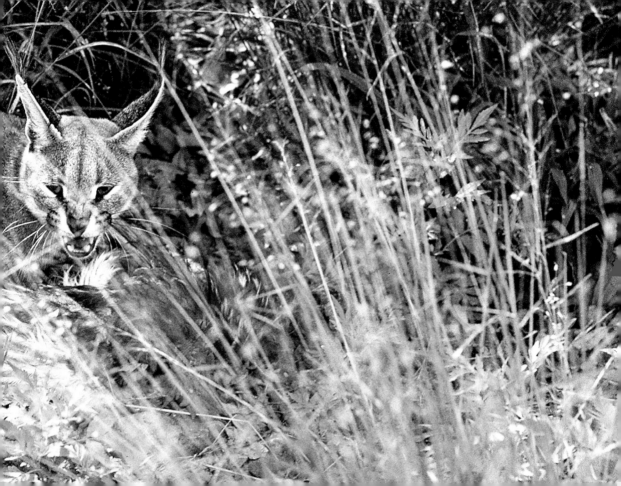

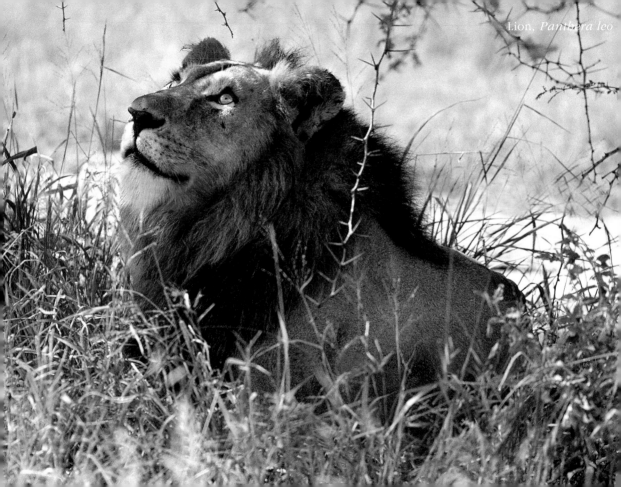

Lion, *Panthera leo*

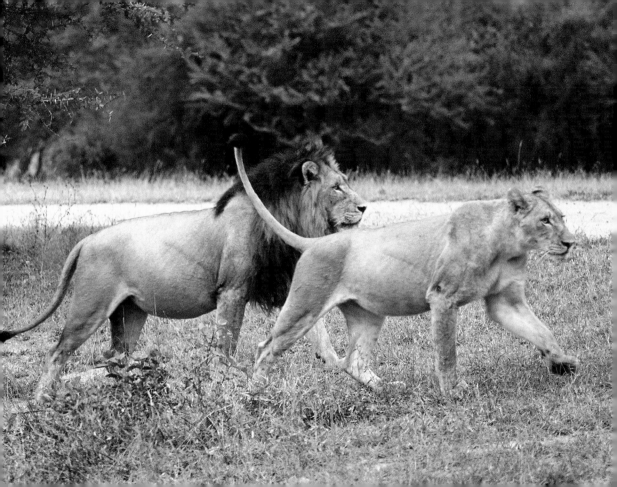

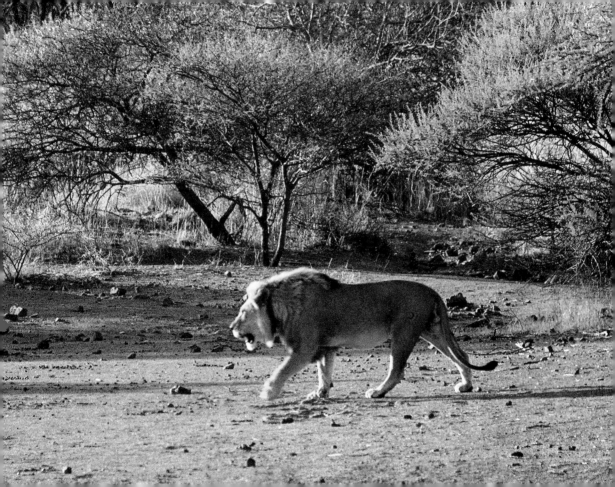

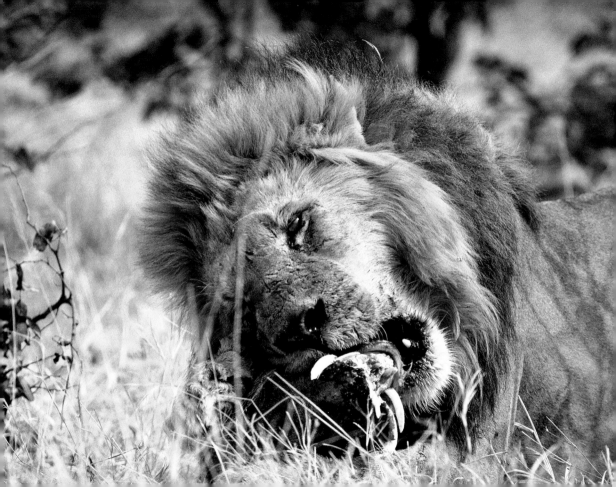

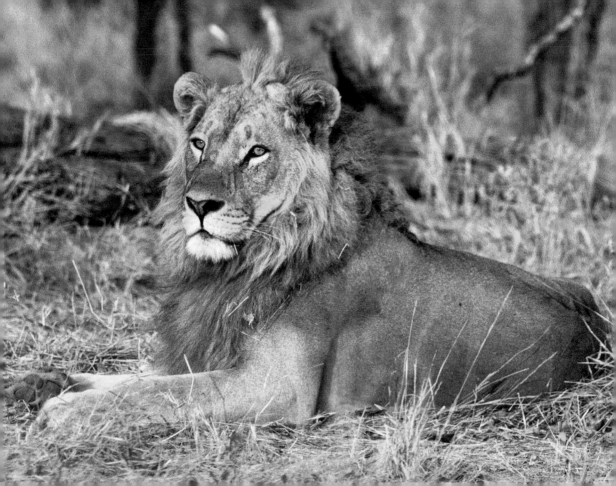

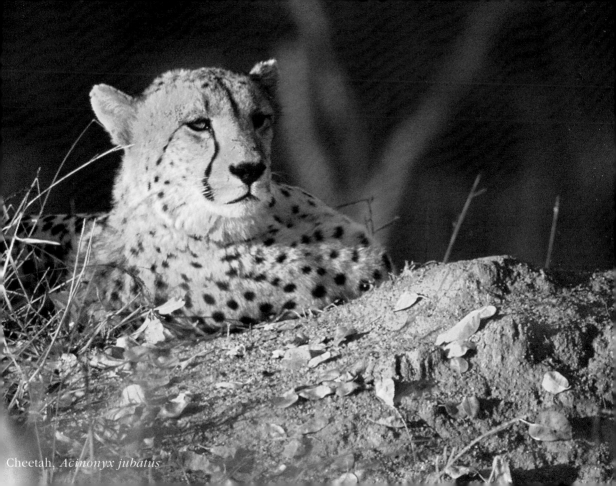

Cheetah, *Acinonyx jubatus*

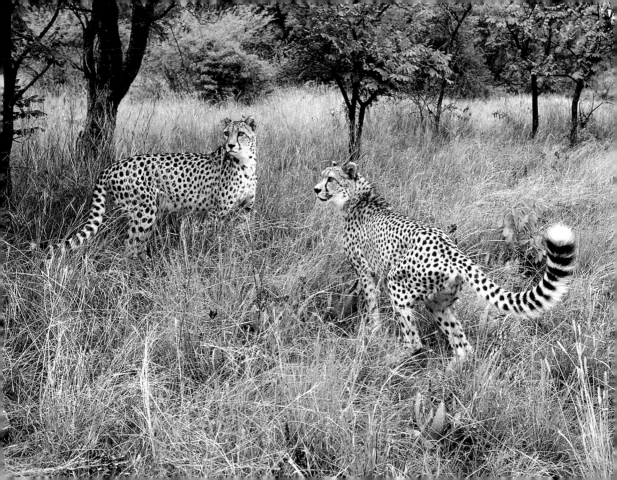

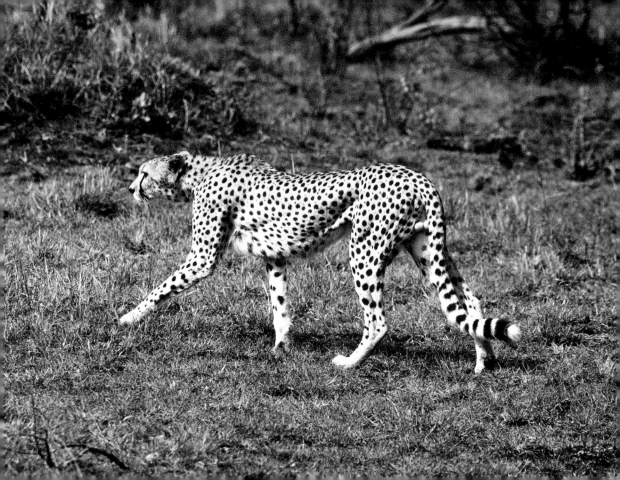

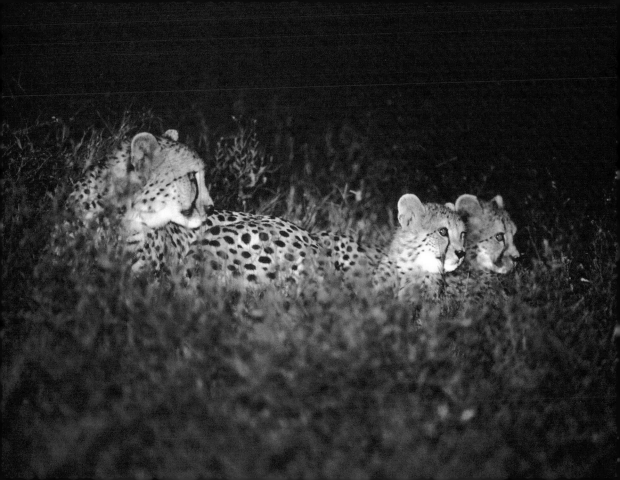

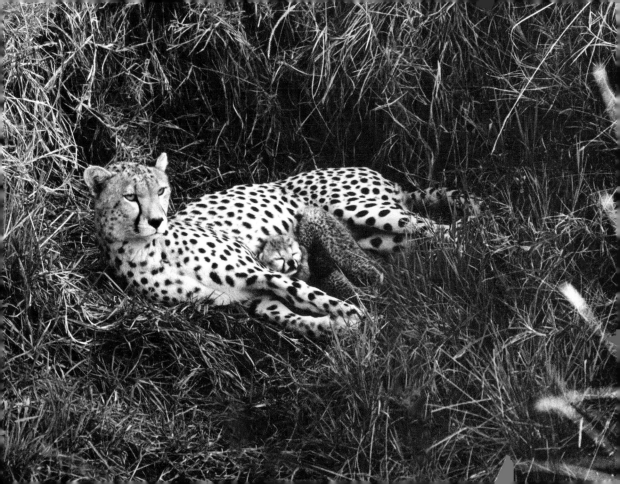

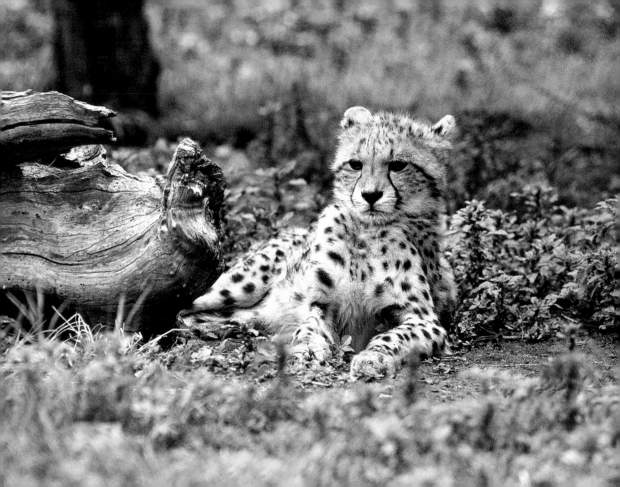

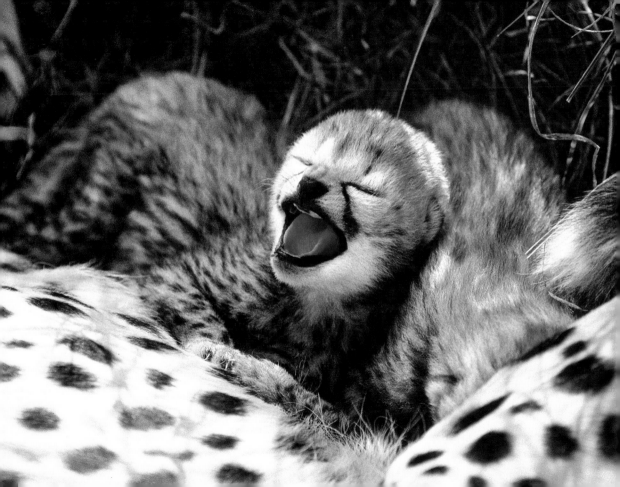

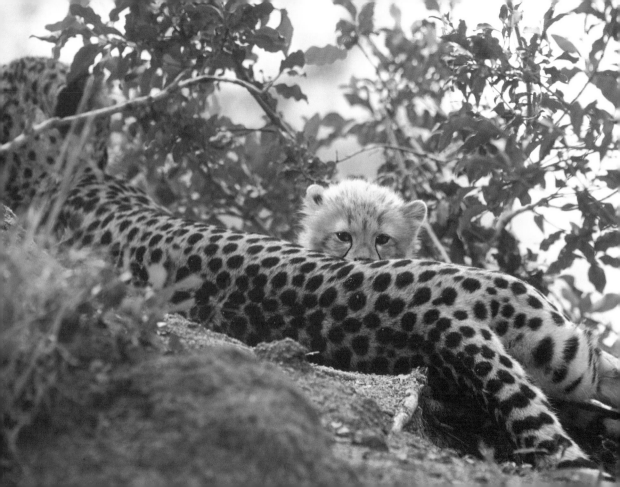

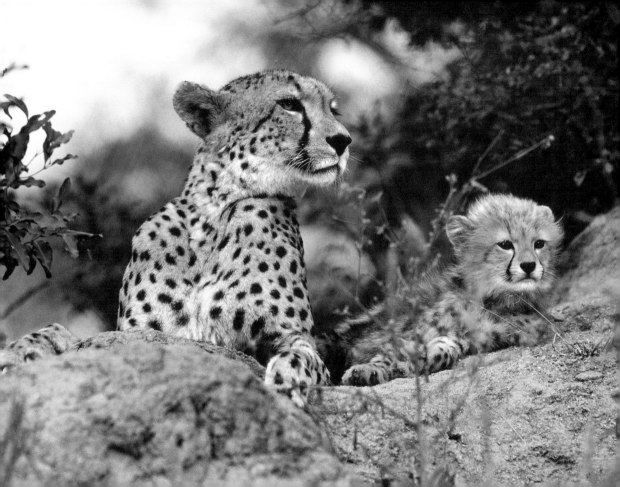

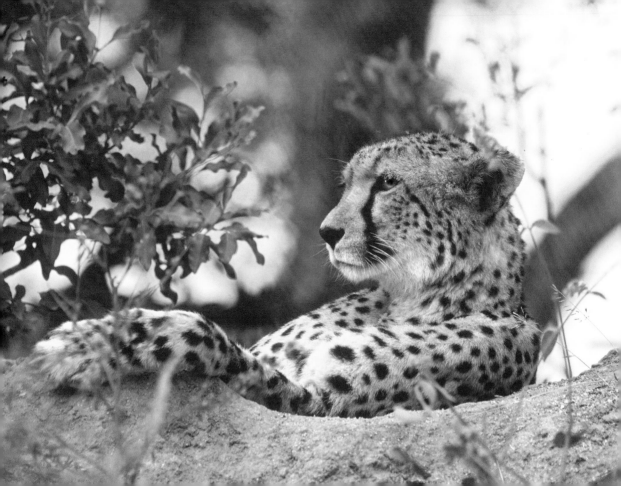

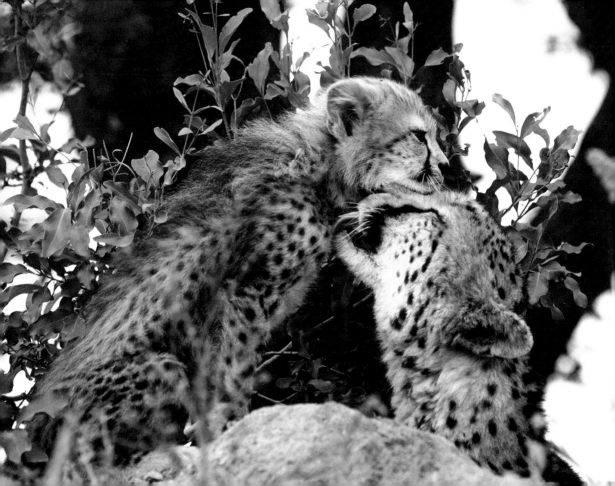

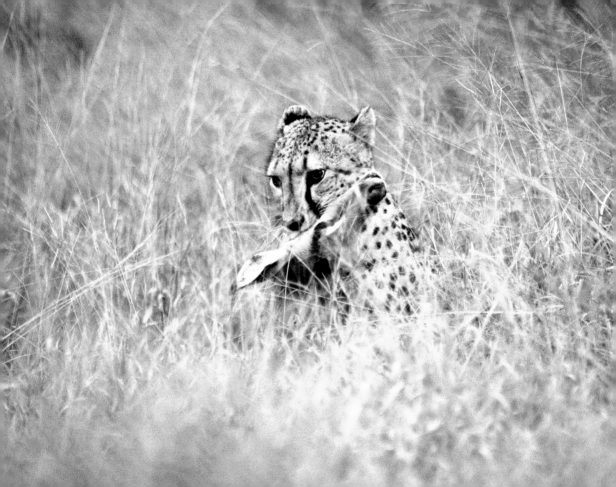

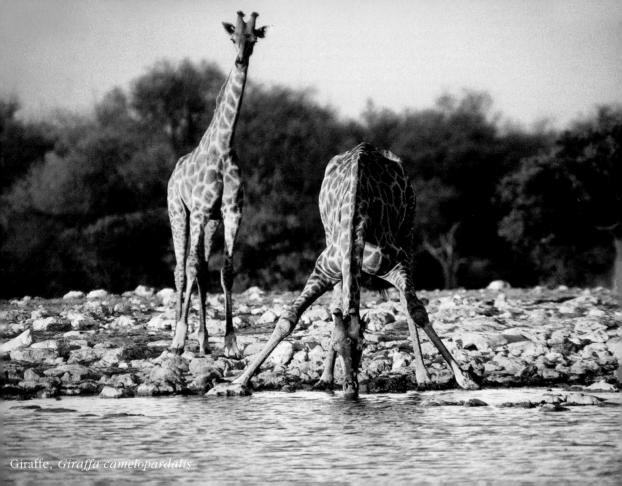

Giraffe, *Giraffa camelopardalis*

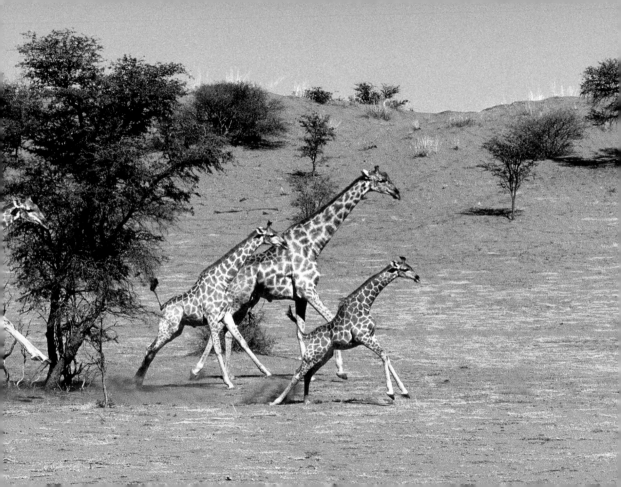

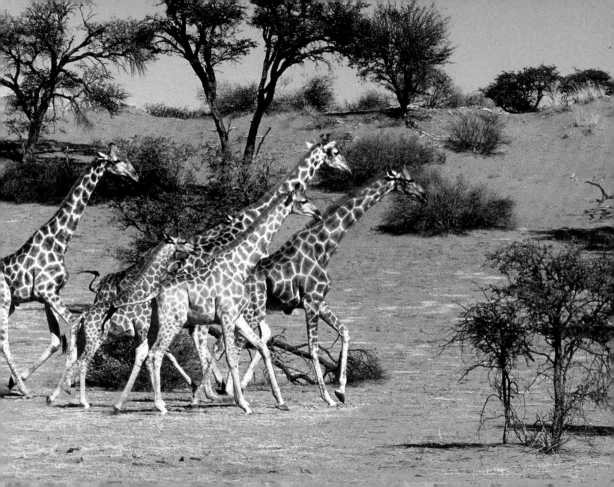

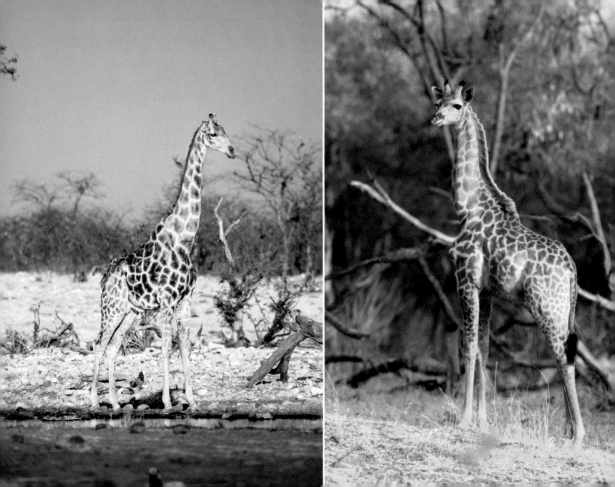

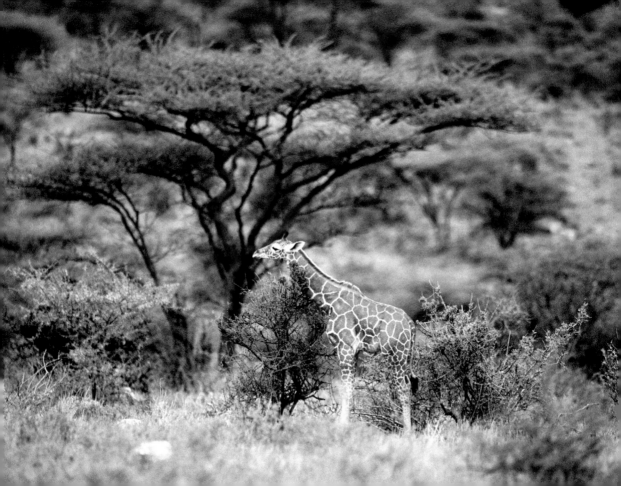

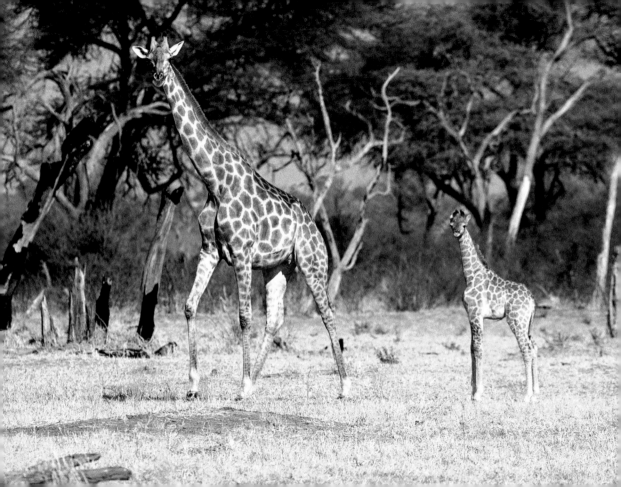

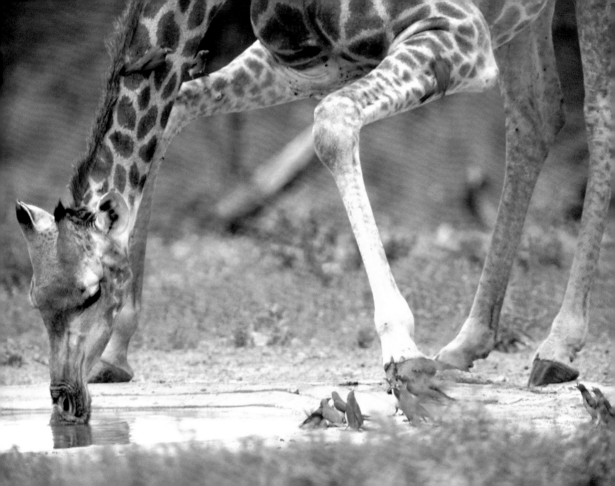

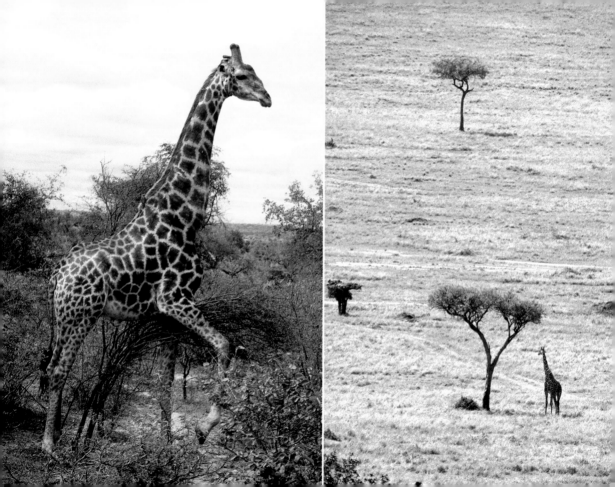

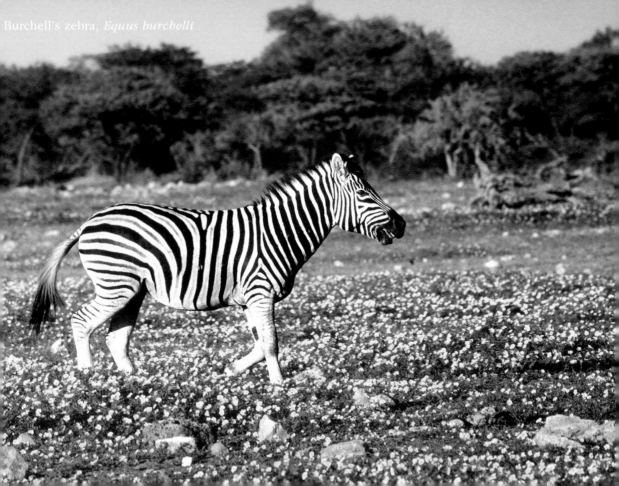
Burchell's zebra, *Equus burchelli*

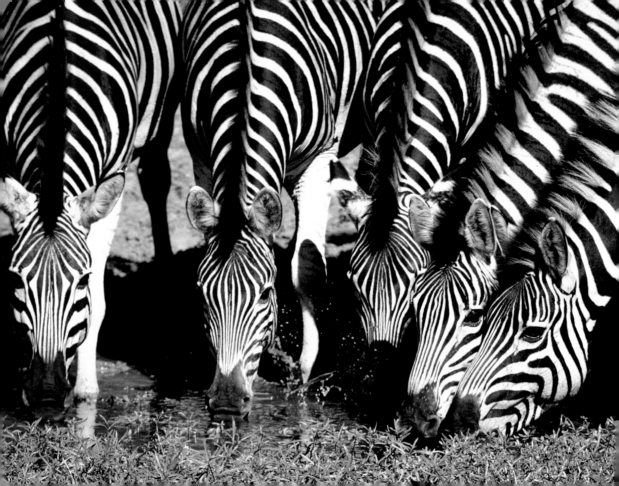

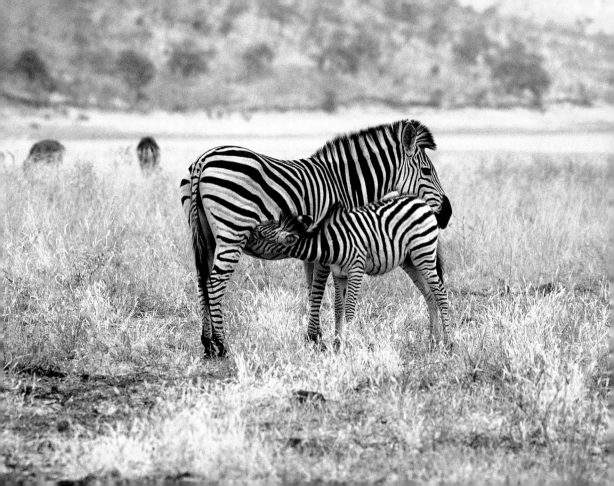

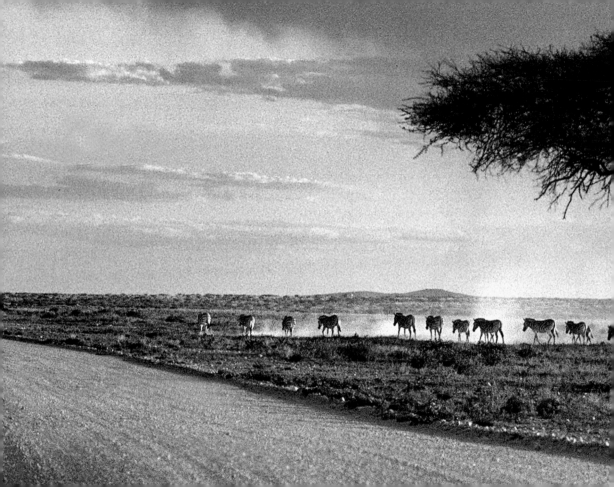

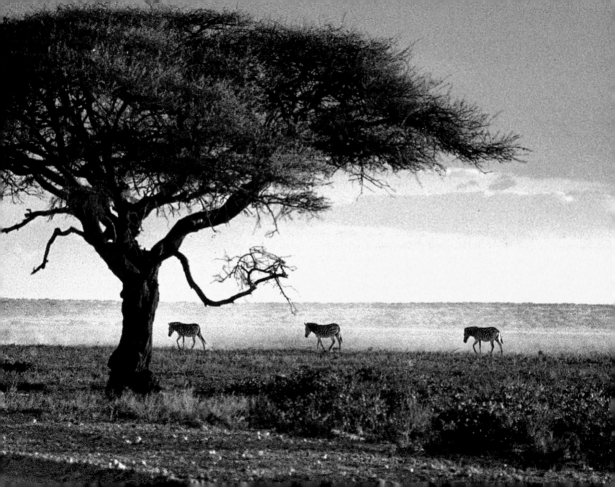

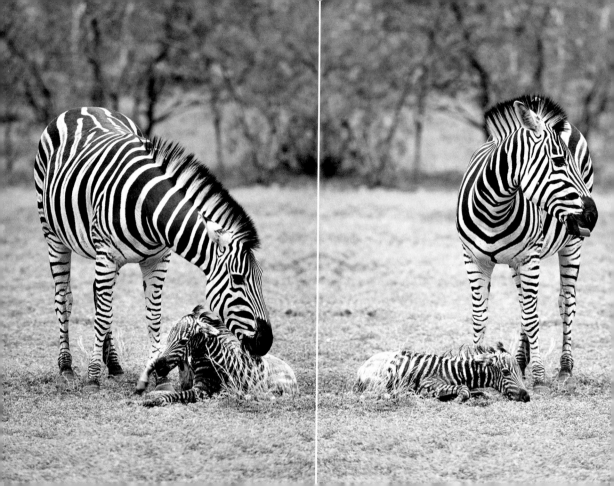

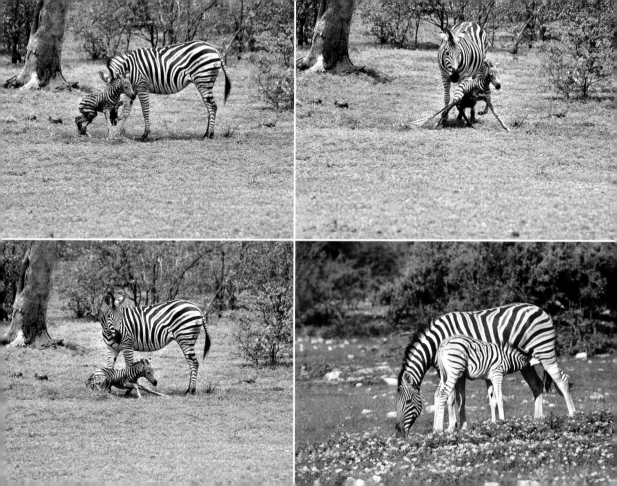

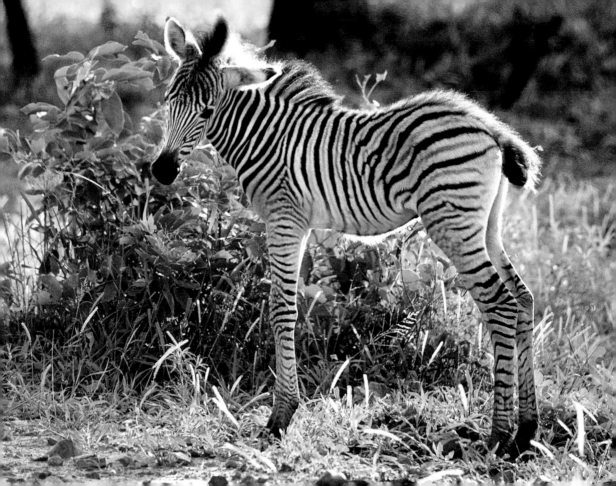

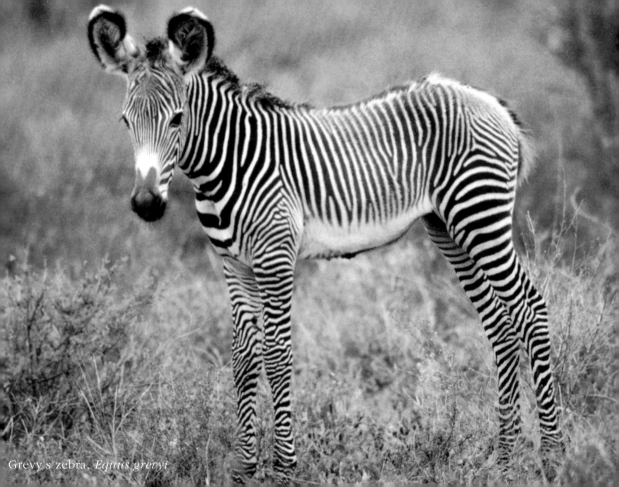

Grevy's zebra, *Equus grevyi*

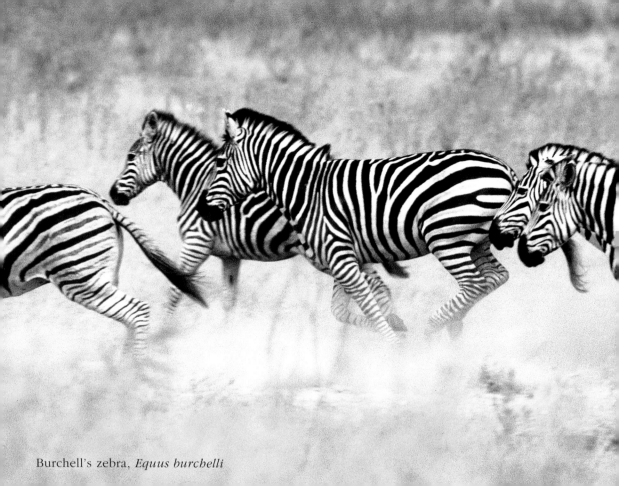

Burchell's zebra, *Equus burchelli*

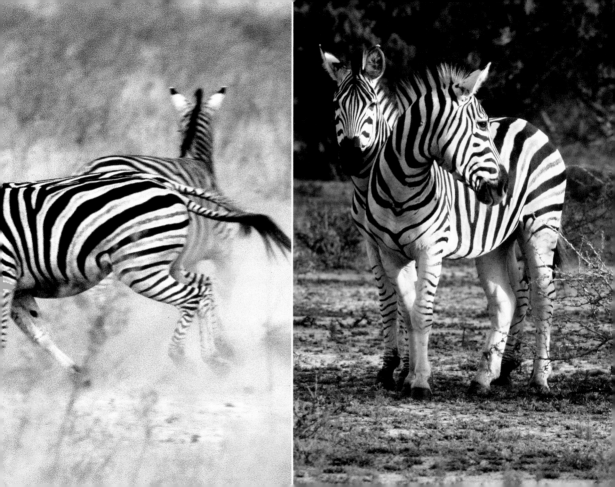

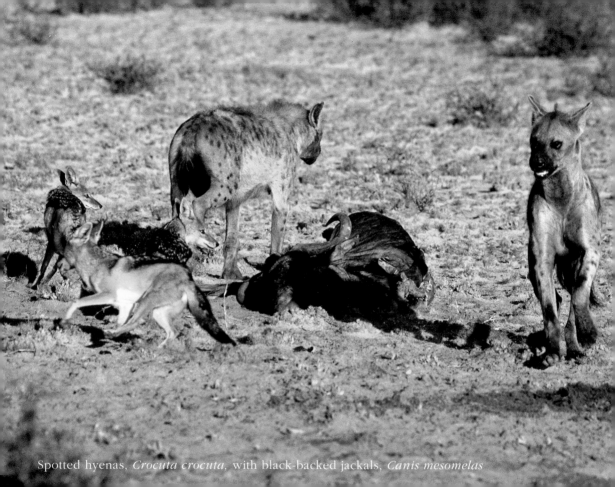

Spotted hyenas, *Crocuta crocuta*, with black-backed jackals, *Canis mesomelas*

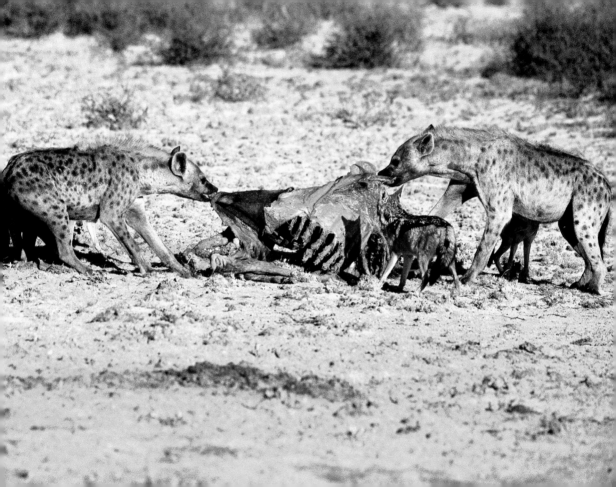

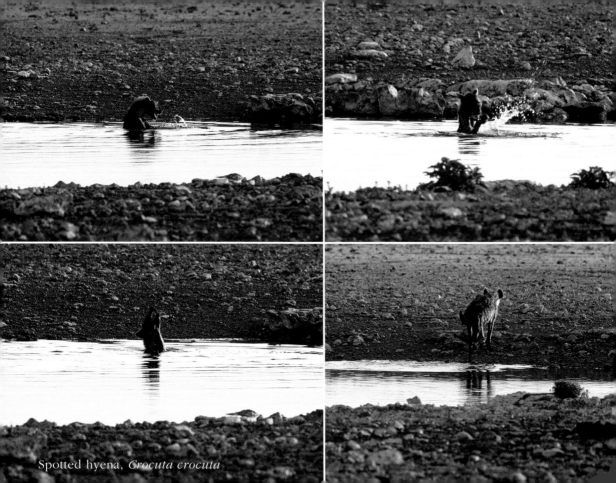

Spotted hyena, *Crocuta crocuta*

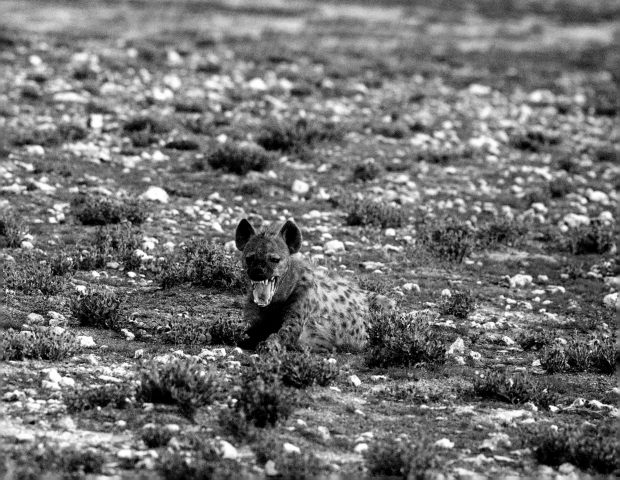

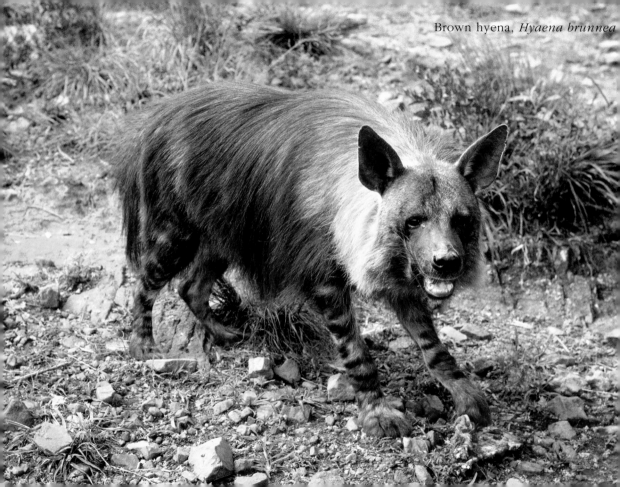

Brown hyena, *Hyaena brunnea*

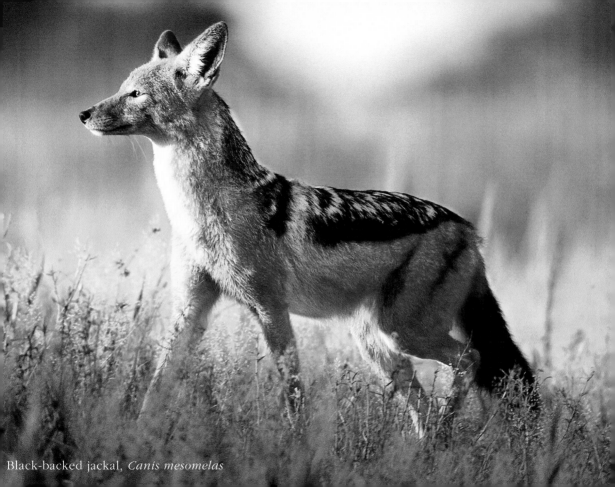

Black-backed jackal, *Canis mesomelas*

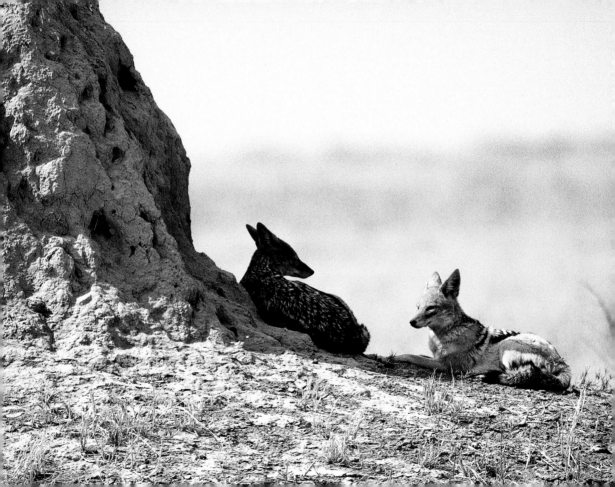

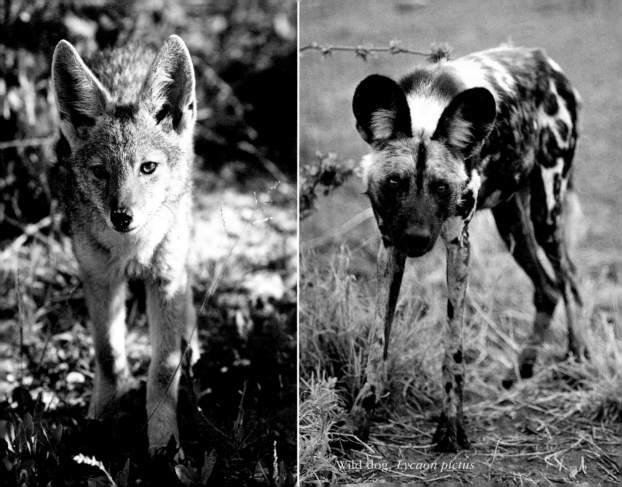

Wild dog, *Lycaon pictus*

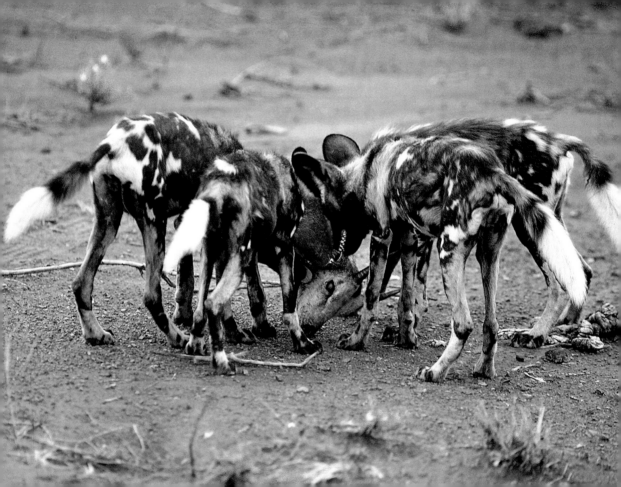

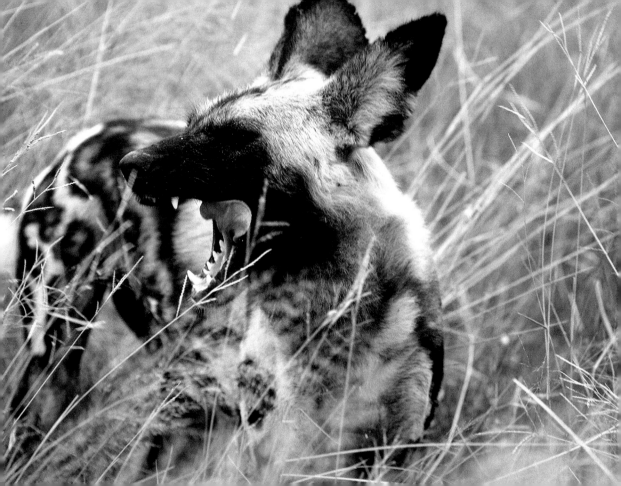

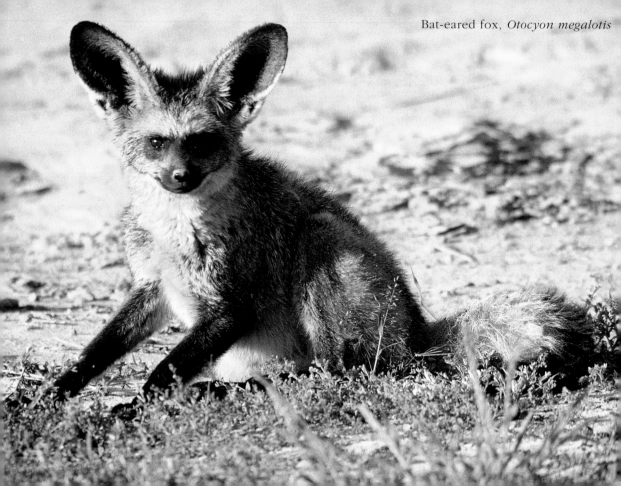

Bat-eared fox, *Otocyon megalotis*

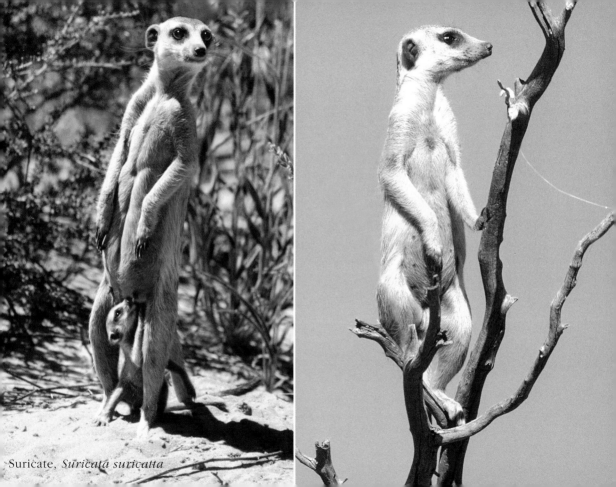

Suricate, *Suricata suricatta*

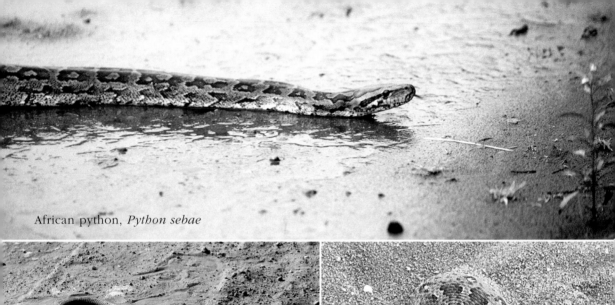

African python, *Python sebae*

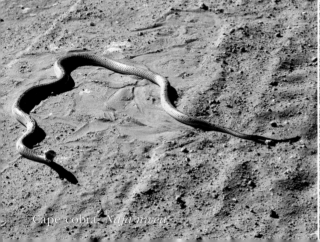

Cape cobra, *Naja nivea*

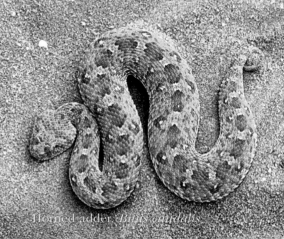

Horned adder, *Bitis caudalis*

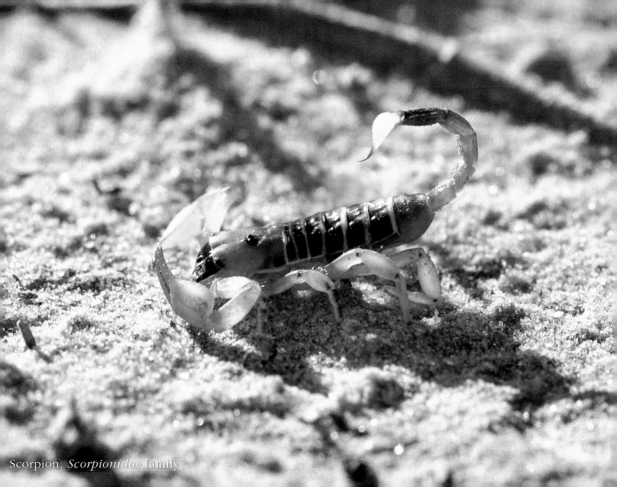

Scorpion, *Scorpionidae* family

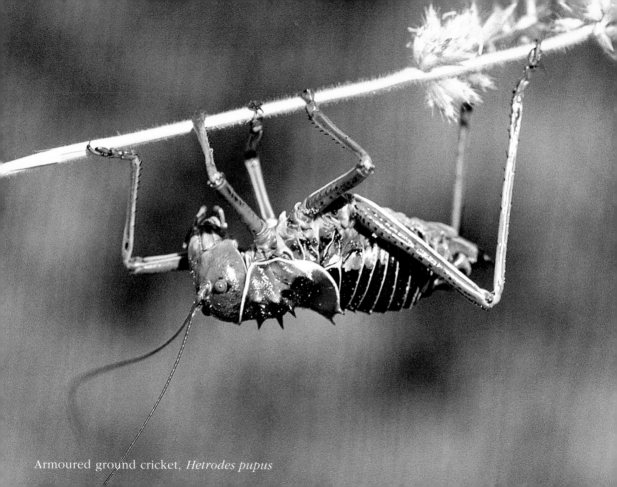

Armoured ground cricket, *Hetrodes pupus*

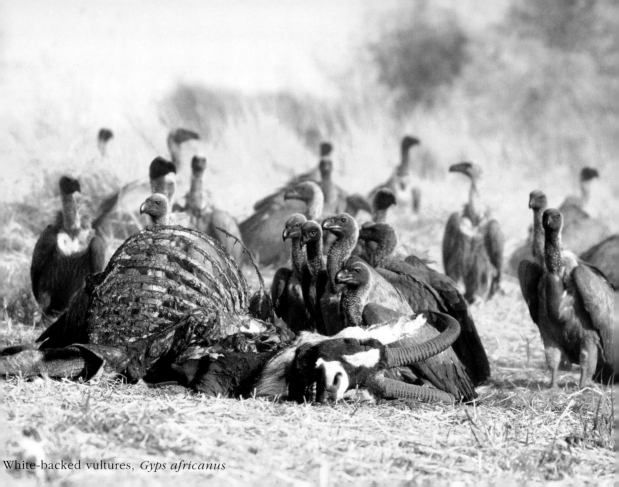

White-backed vultures, *Gyps africanus*

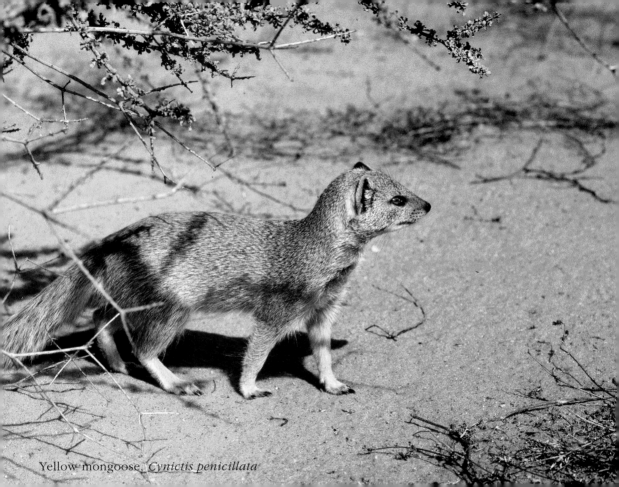

Yellow mongoose, *Cynictis penicillata*

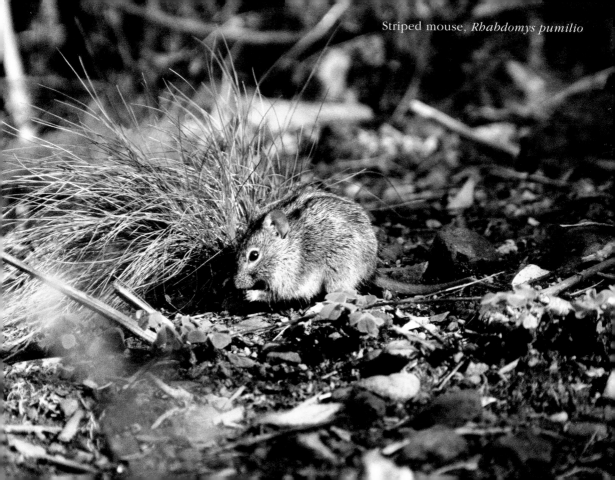

Striped mouse, *Rhabdomys pumilio*

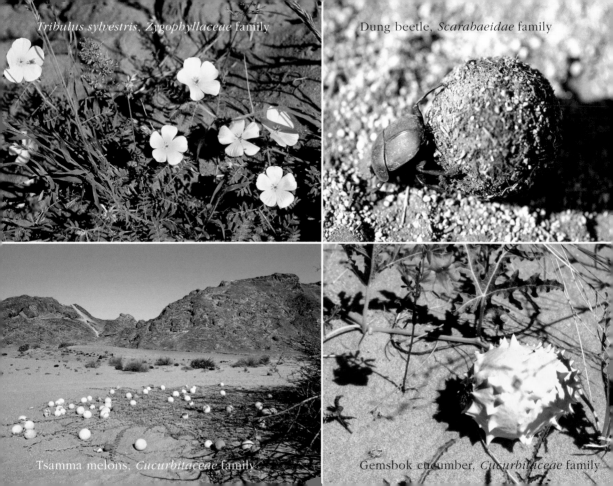

Tribulus sylvestris, Zygophyllaceae family

Dung beetle, *Scarabaeidae* family

Tsamma melons, *Cucurbitaceae* family

Gemsbok cucumber, *Cucurbitaceae* family

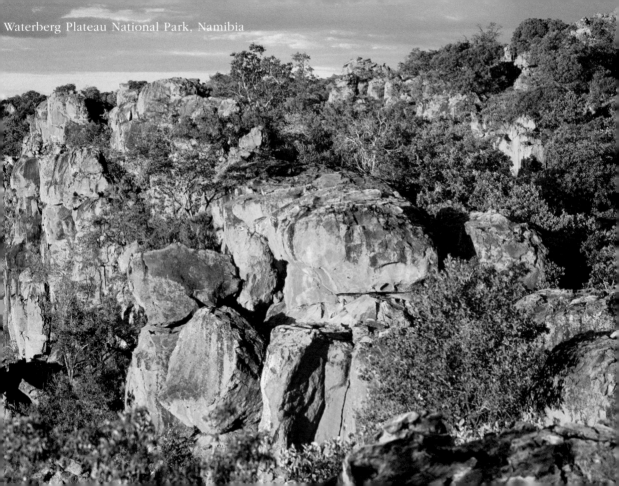
Waterberg Plateau National Park, Namibia

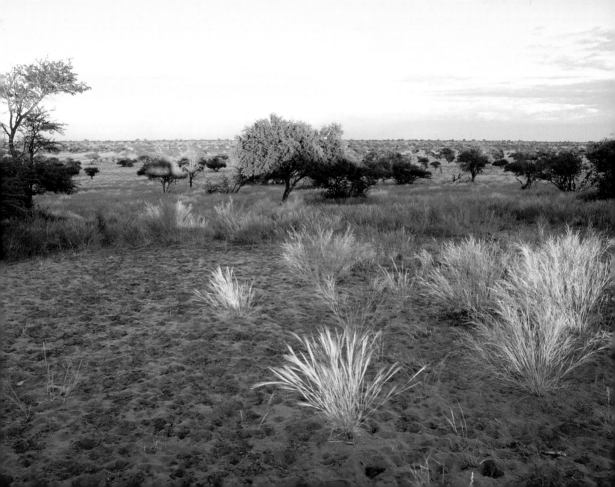

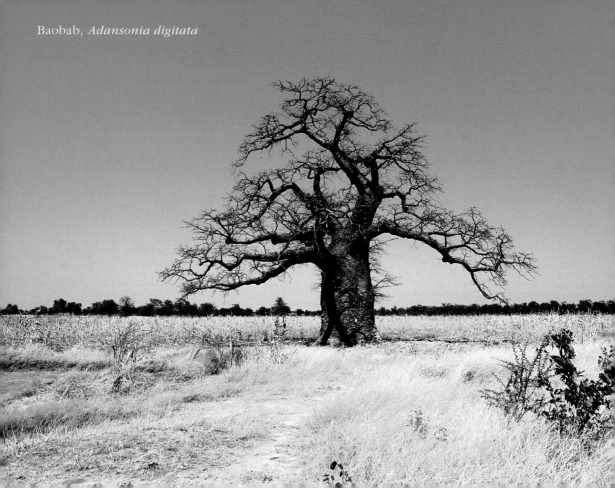

Baobab, *Adansonia digitata*

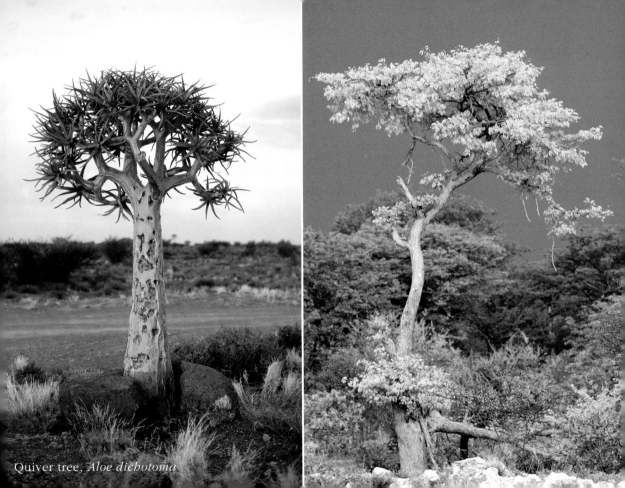

Quiver tree, *Aloe dichotoma*

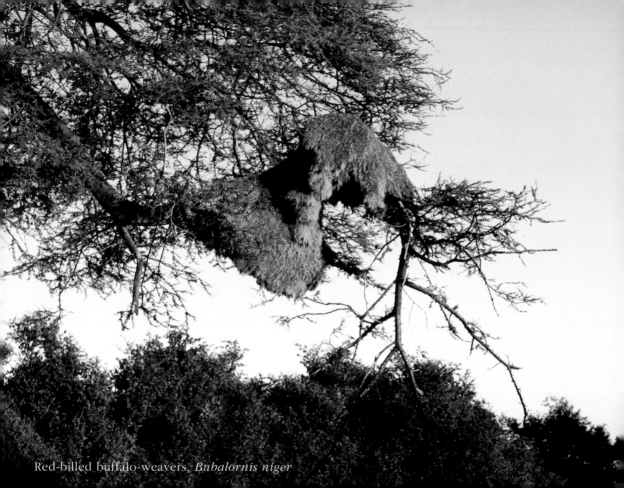

Red-billed buffalo-weavers, *Bubalornis niger*

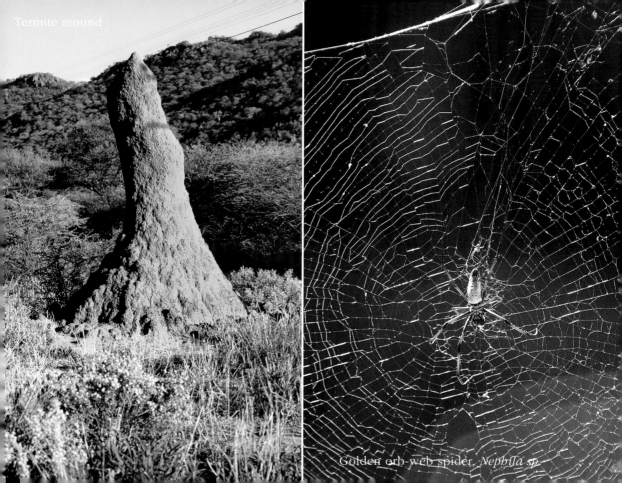

Termite mound

Golden orb-web spider, *Nephila* sp.

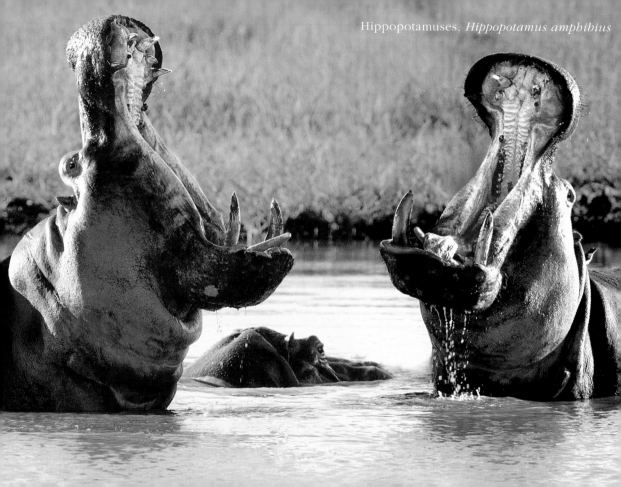

Hippopotamuses, *Hippopotamus amphibius*

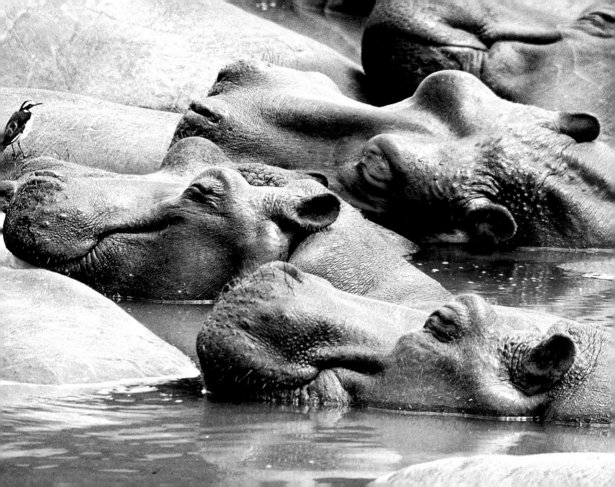

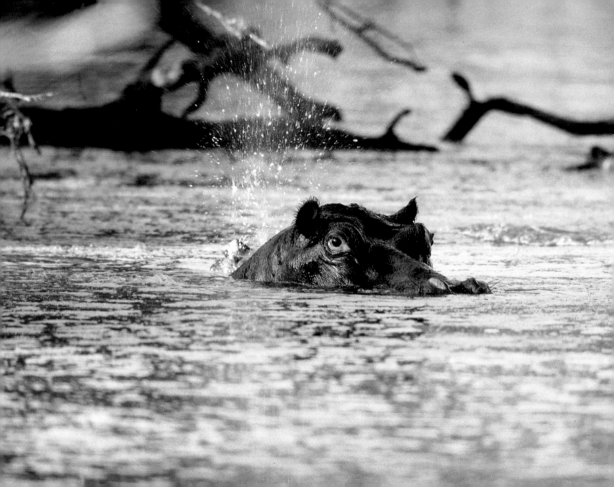

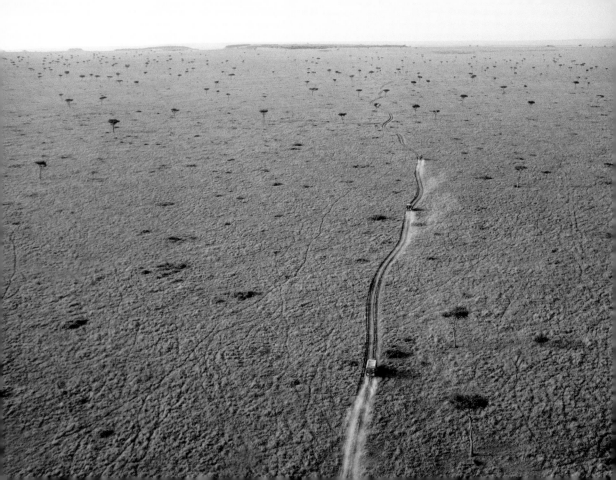

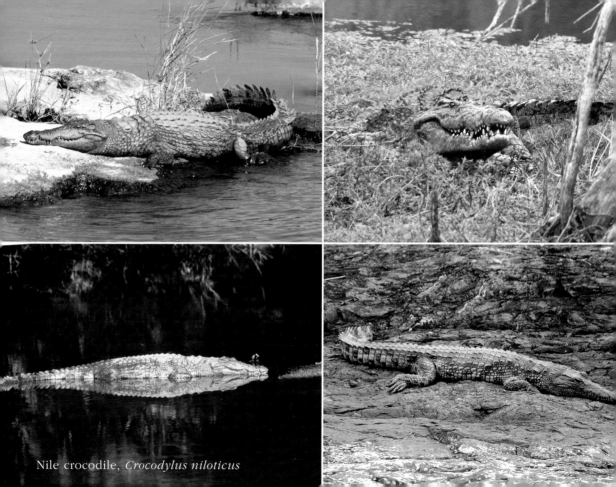

Nile crocodile, *Crocodylus niloticus*

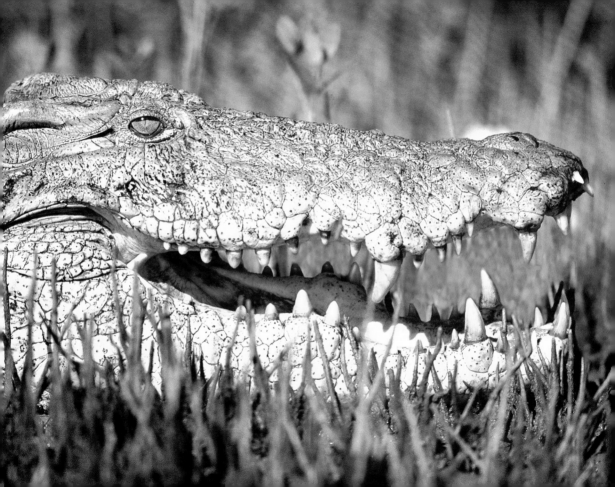

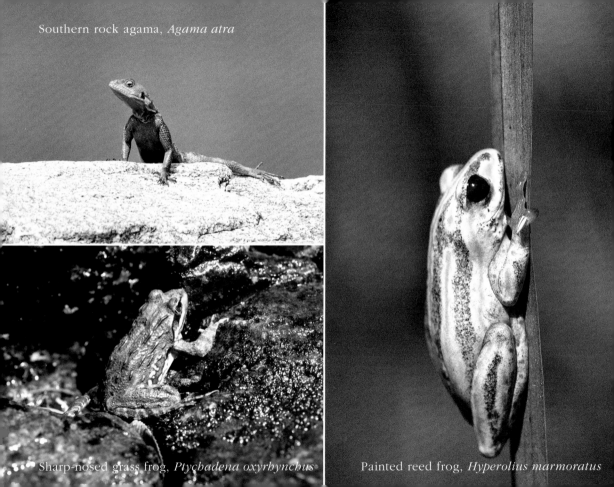

Southern rock agama, *Agama atra*

Sharp-nosed grass frog, *Ptychadena oxyrhynchus*

Painted reed frog, *Hyperolius marmoratus*

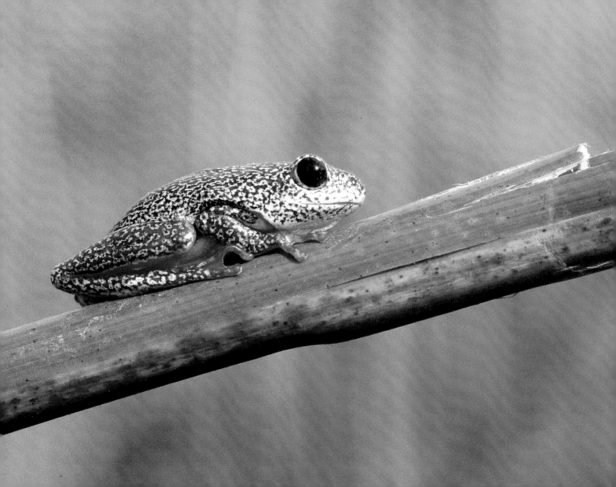

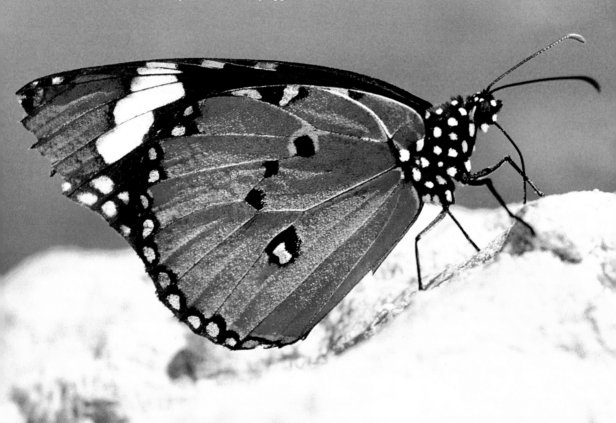
African monarch butterfly, *Danaus chrysippus*

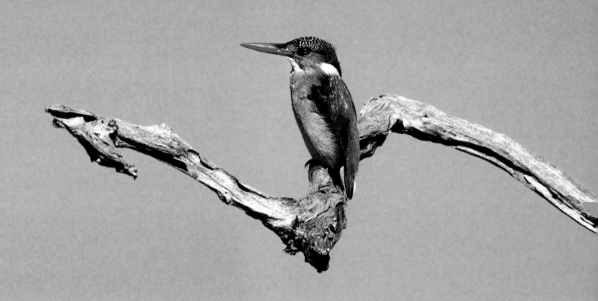

Malachite kingfisher, *Alcedo cristata*

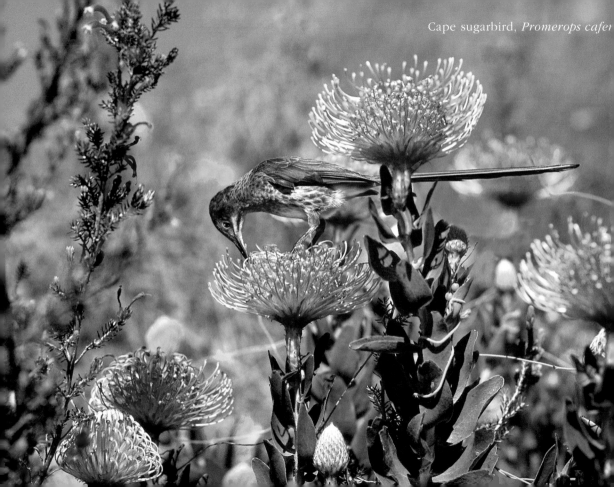
Cape sugarbird, *Promerops cafer*

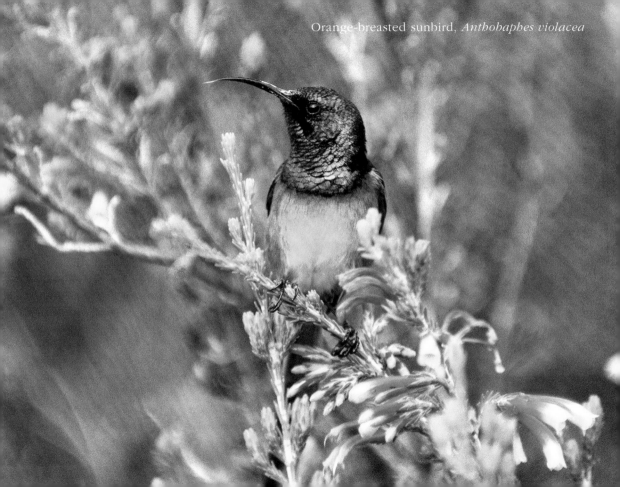
Orange-breasted sunbird, *Anthobaphes violacea*

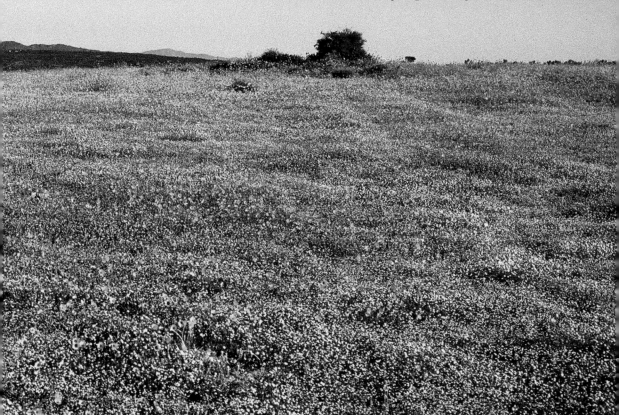
Wild flowers in spring, Namaqualand, South Africa

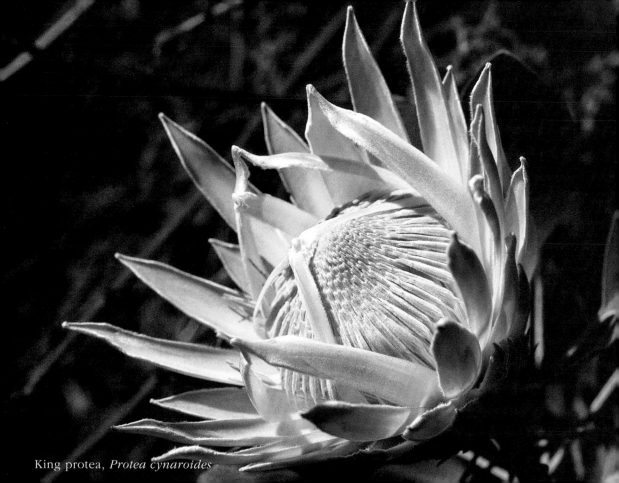

King protea, *Protea cynaroides*

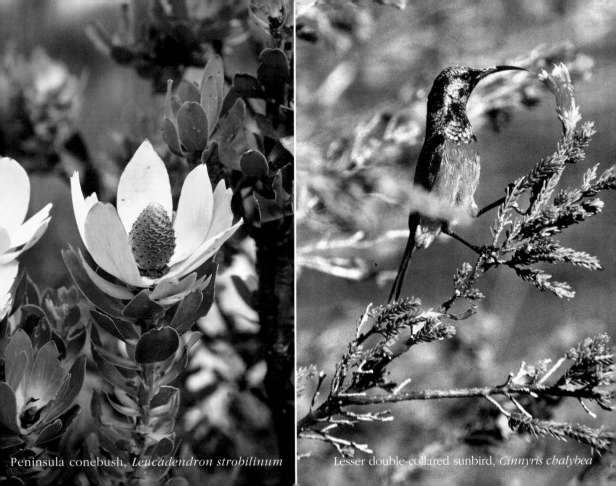

Peninsula conebush, *Leucadendron strobilinum*

Lesser double-collared sunbird, *Cinnyris chalybea*

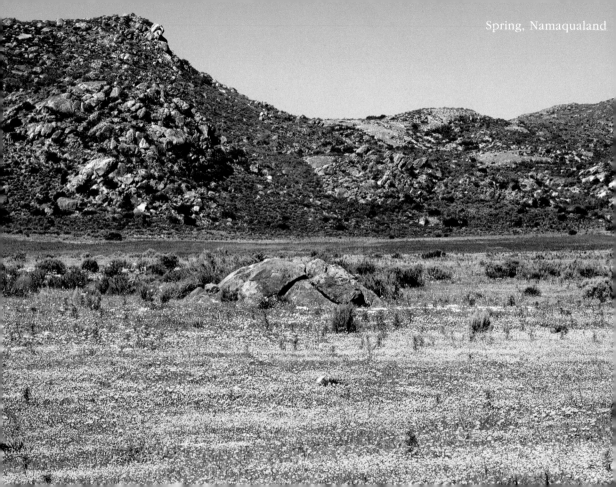

Spring, Namaqualand

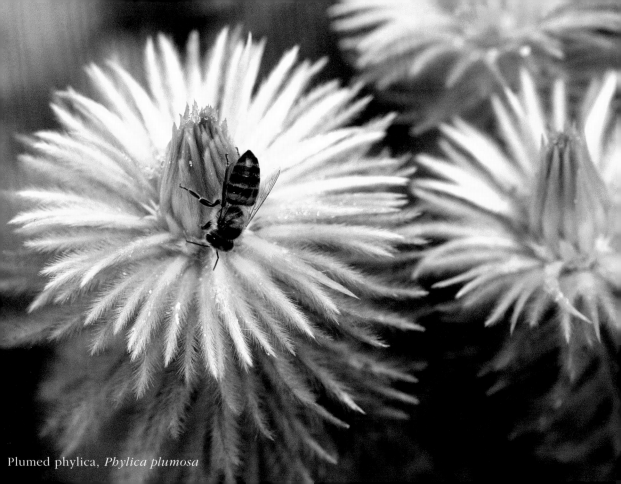

Plumed phylica, *Phylica plumosa*

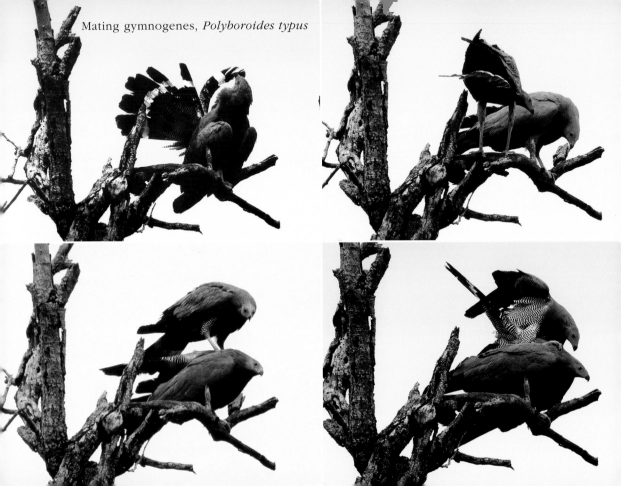

Mating gymnogenes, *Polyboroides typus*

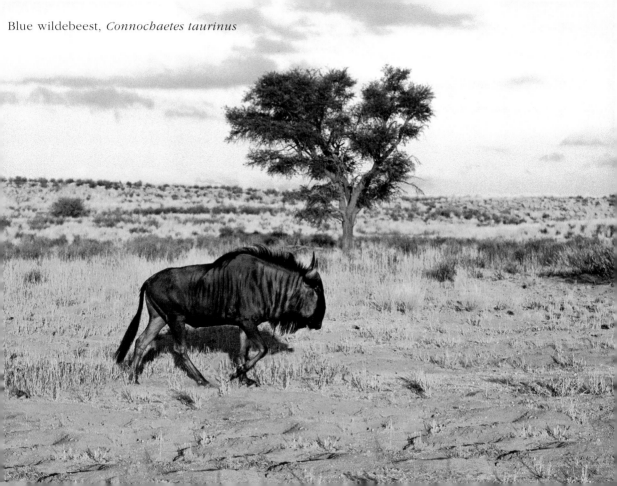

Blue wildebeest, *Connochaetes taurinus*

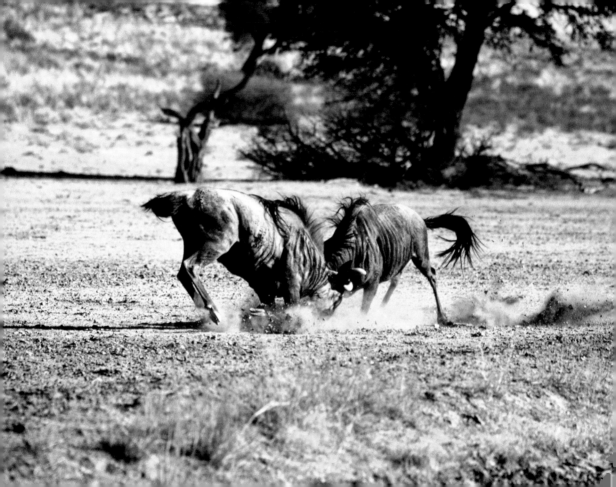

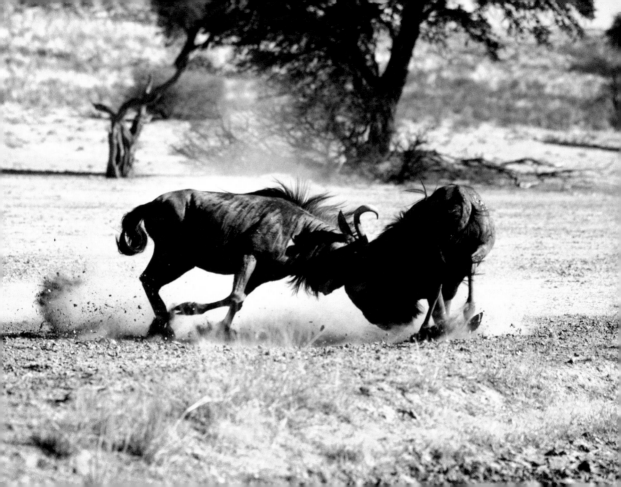

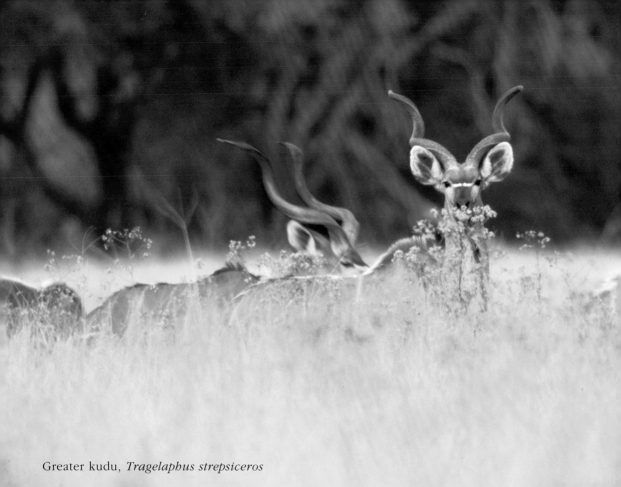

Greater kudu, *Tragelaphus strepsiceros*

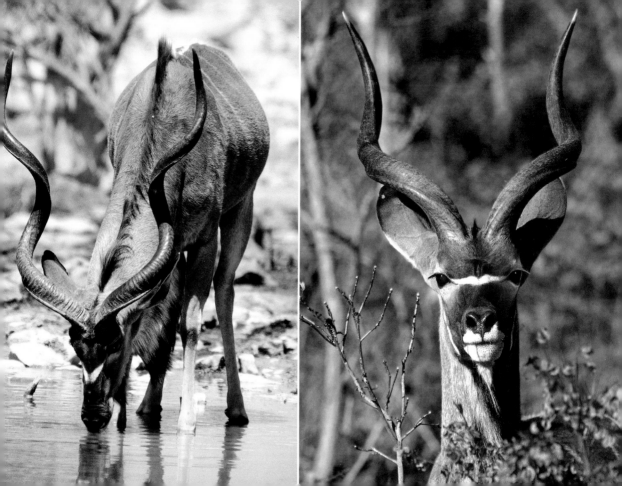

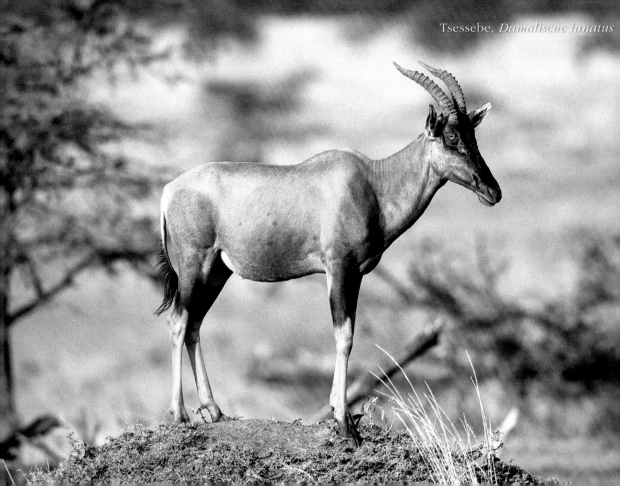

Tsessebe, *Damaliscus lunatus*

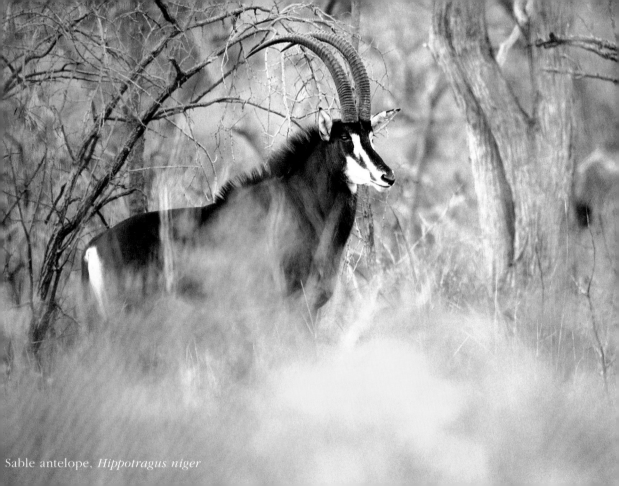

Sable antelope, *Hippotragus niger*

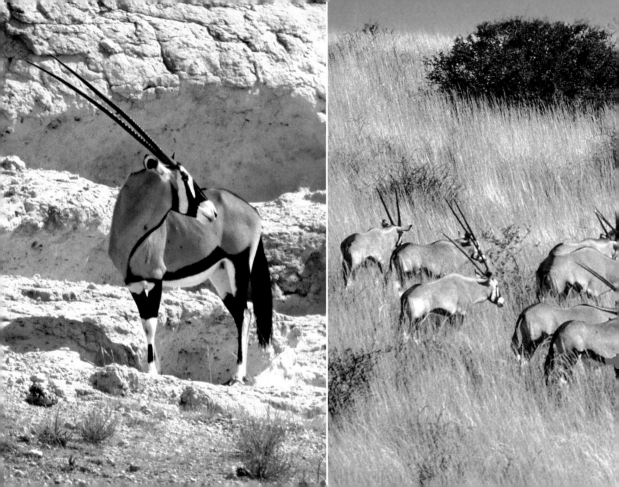

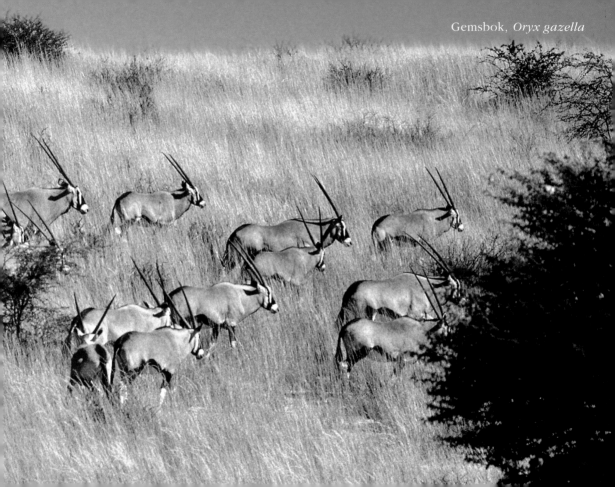

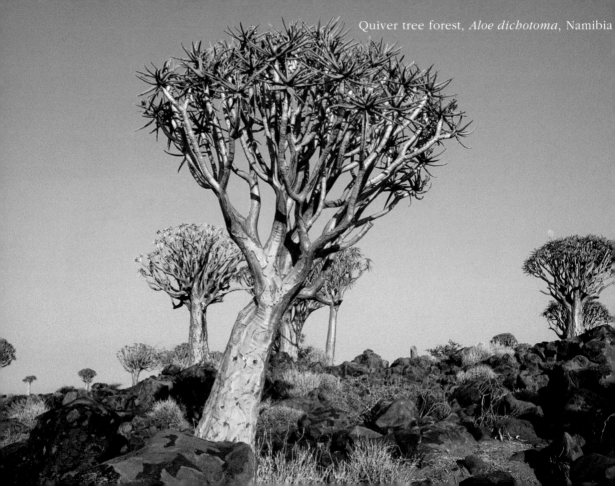

Quiver tree forest, *Aloe dichotoma*, Namibia

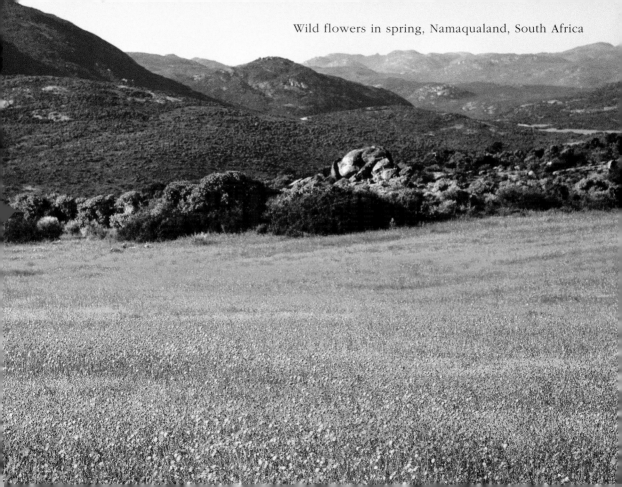
Wild flowers in spring, Namaqualand, South Africa

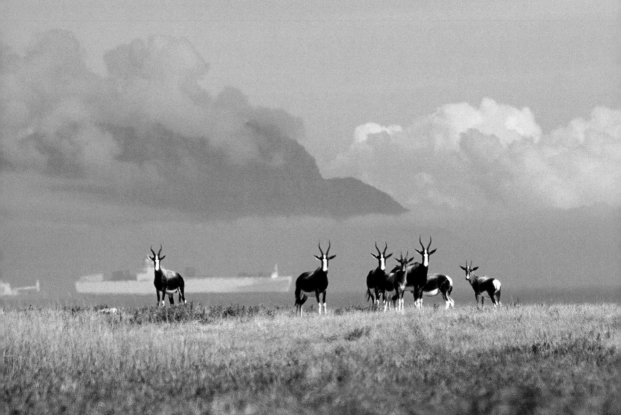
Bontebok, *Damaliscus dorcas*, Robben Island

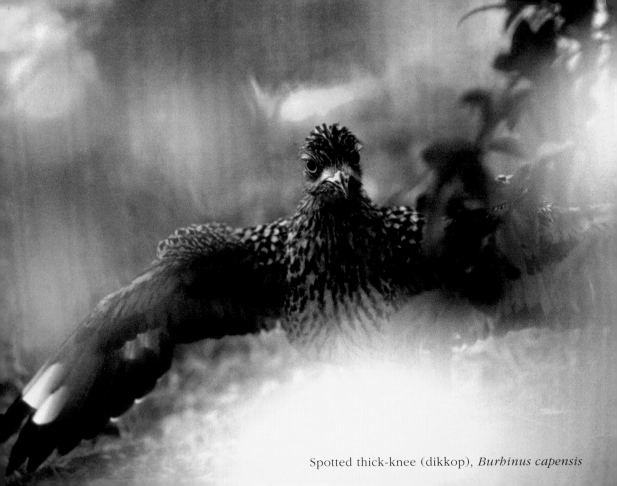

Spotted thick-knee (dikkop), *Burhinus capensis*

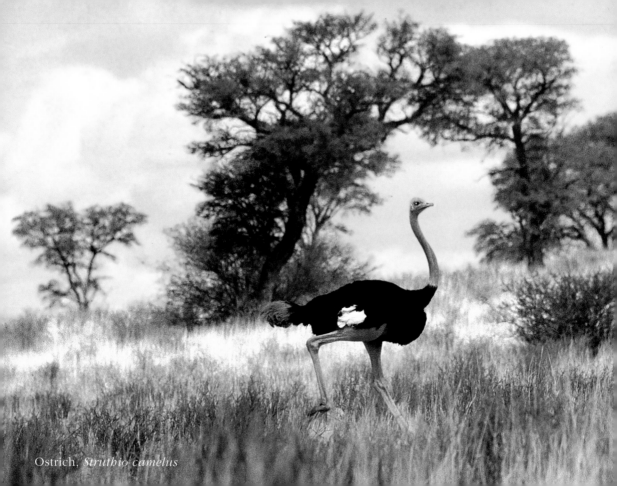

Ostrich, *Struthio camelus*

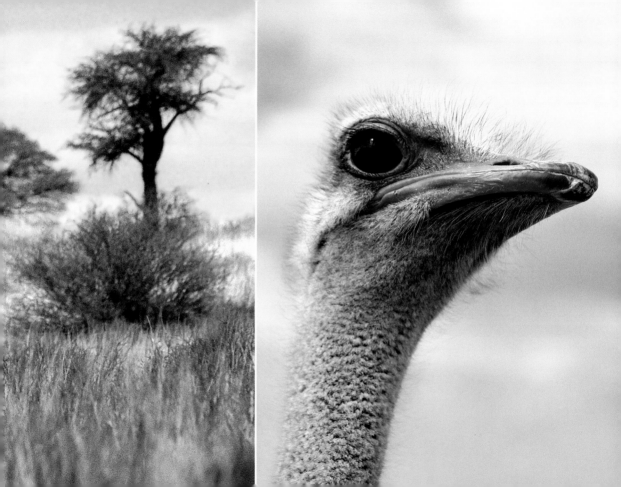

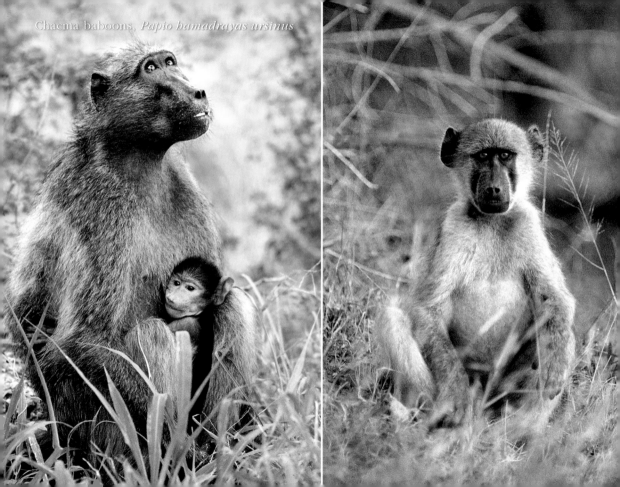

Chacma baboons, *Papio hamadrayas ursinus*

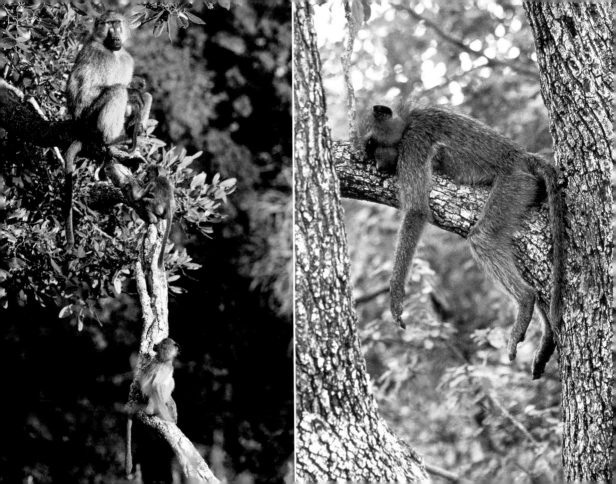

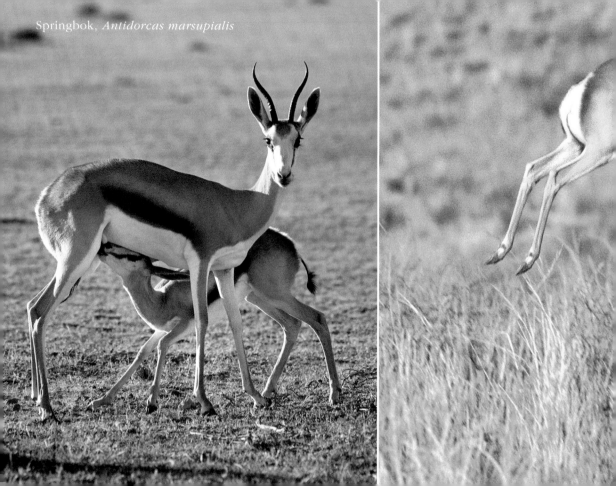

Springbok, *Antidorcas marsupialis*

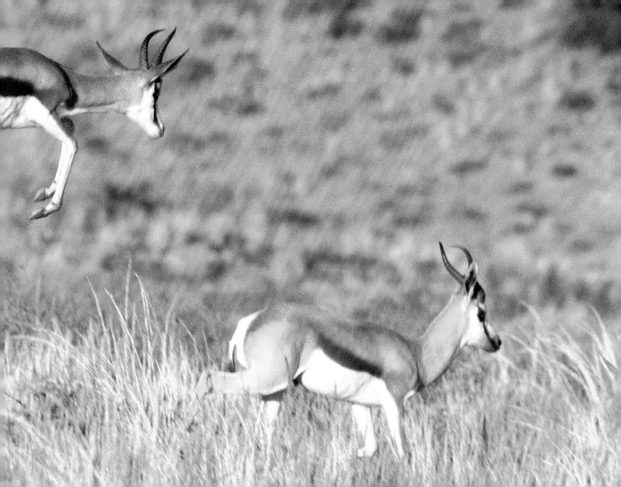

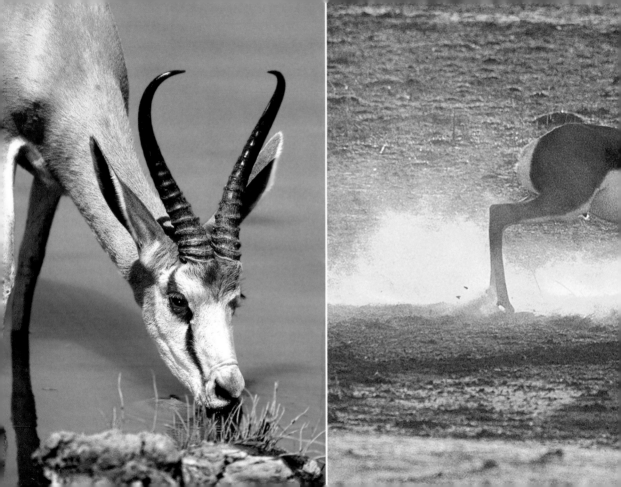

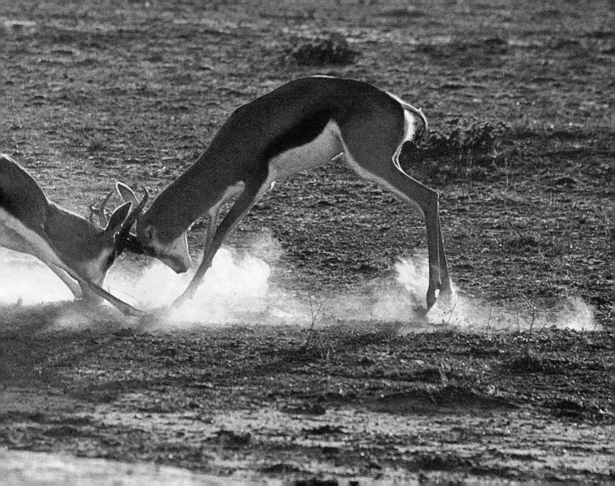

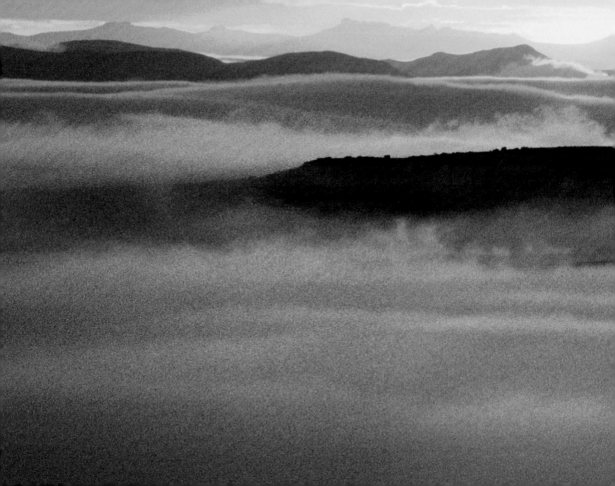

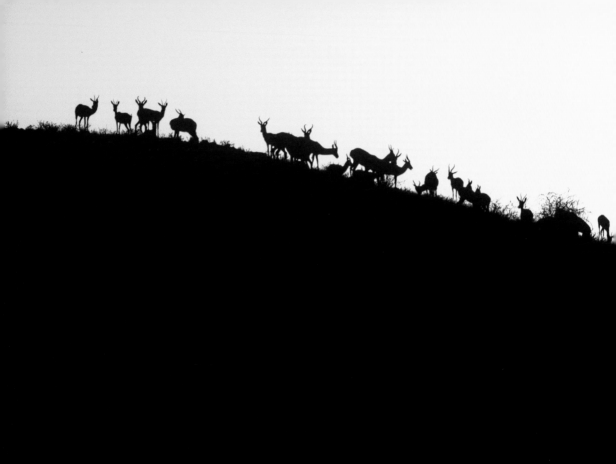

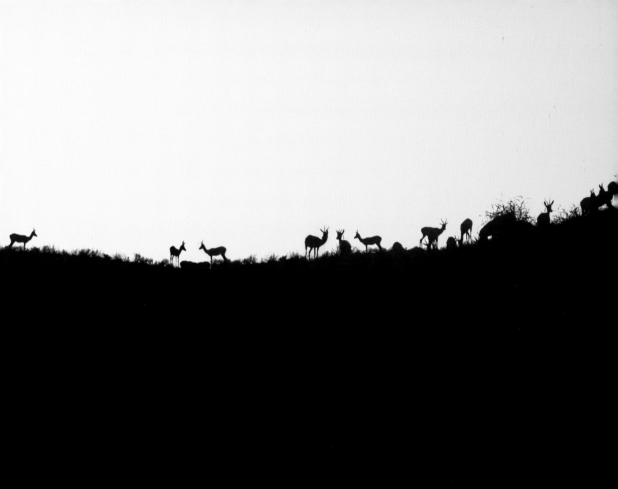

Cape eagle-owl, *Bubo capensis*

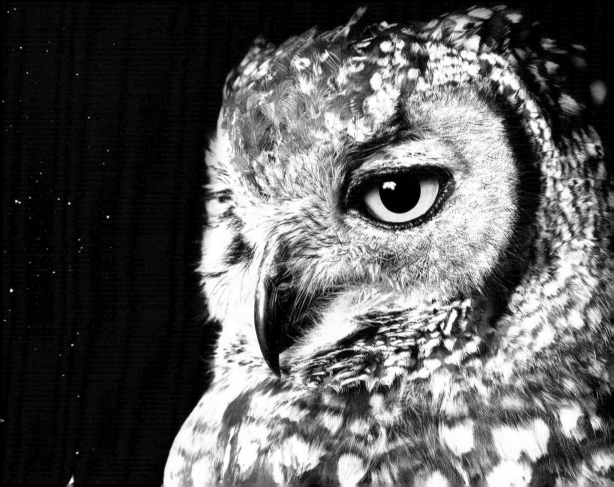

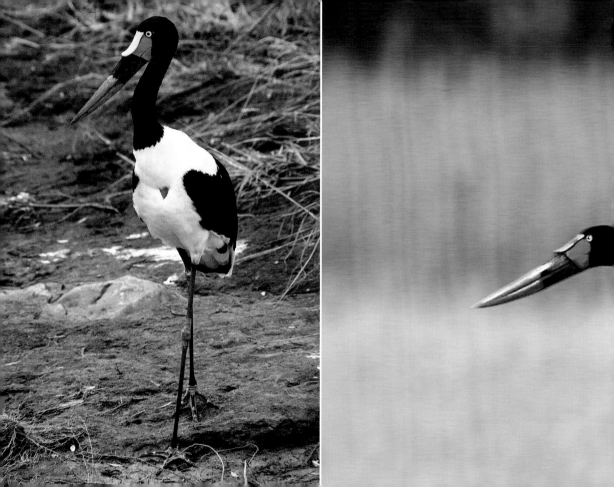

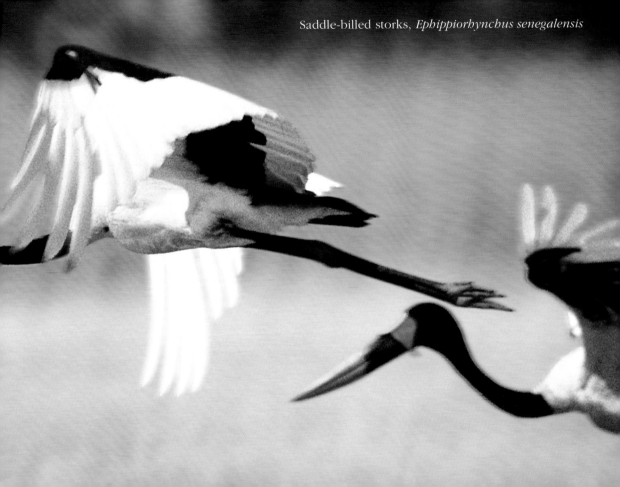

Saddle-billed storks, *Ephippiorhynchus senegalensis*

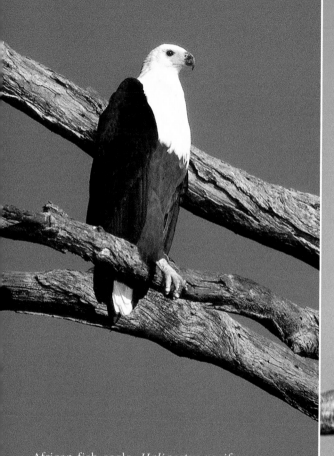
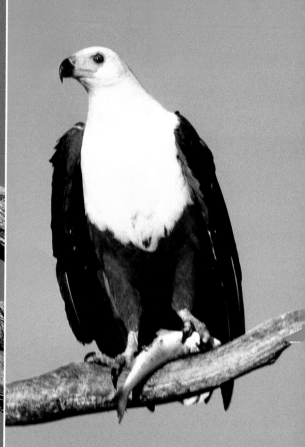

African fish eagle, *Haliaeetus vocifer*

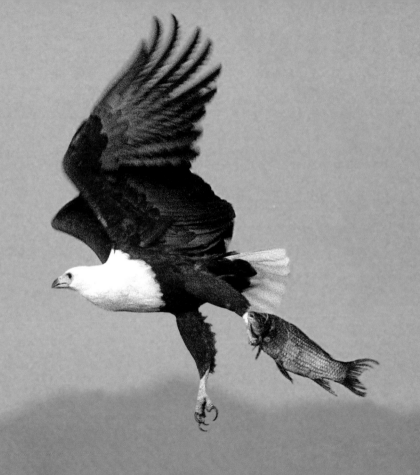

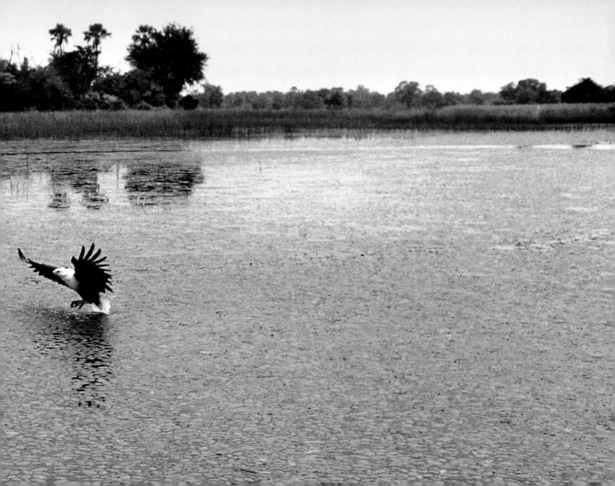

Bateleur eagle, *Terathopius ecaudatus*

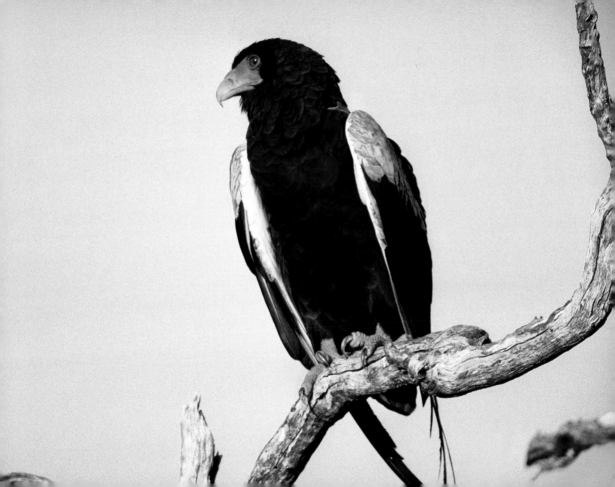

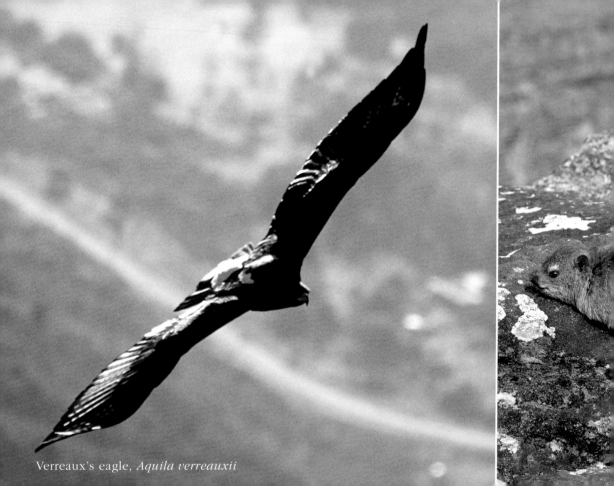

Verreaux's eagle, *Aquila verreauxii*

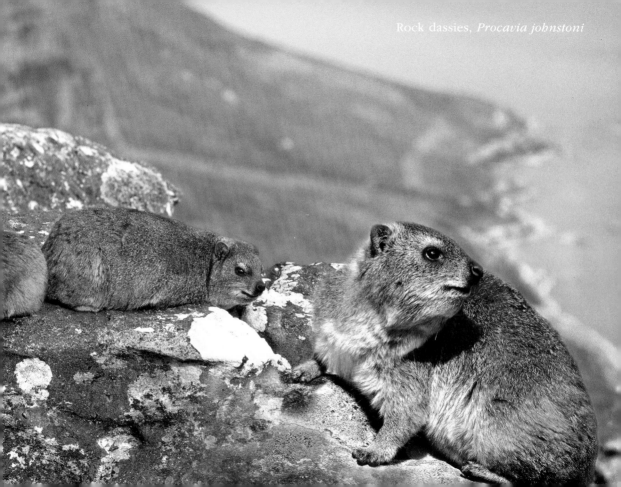

Rock dassies, *Procavia johnstoni*

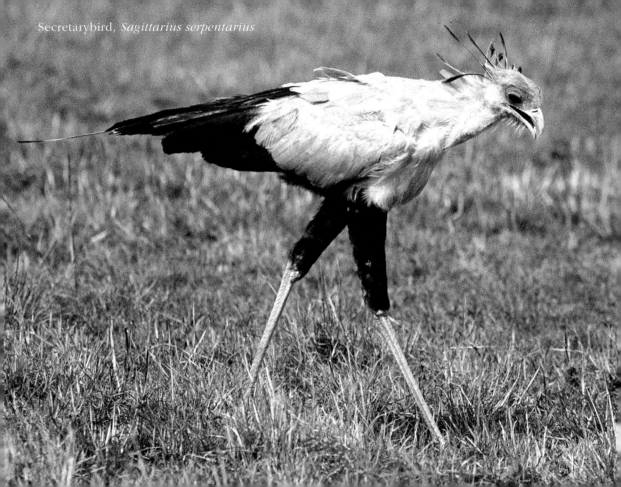

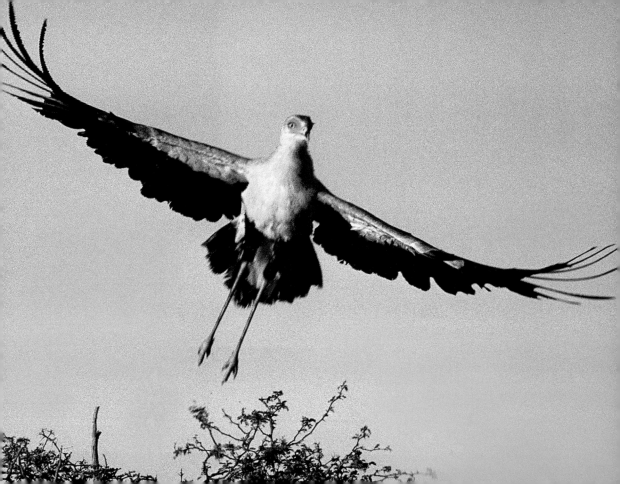

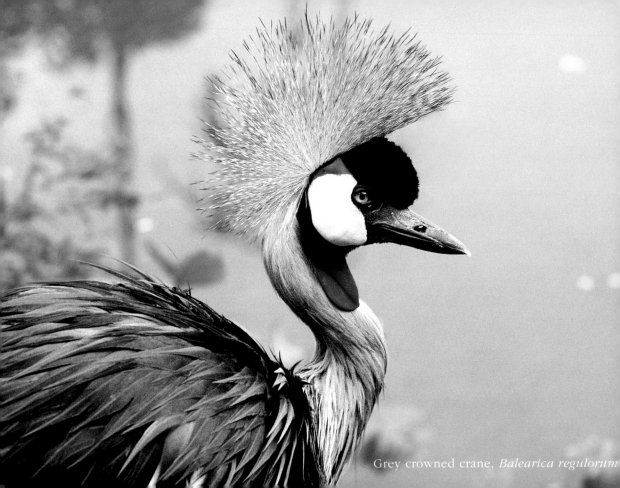

Grey crowned crane, *Balearica regulorum*

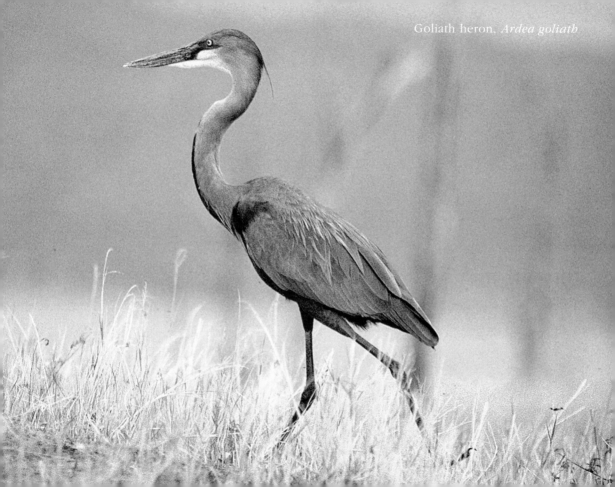

Goliath heron, *Ardea goliath*

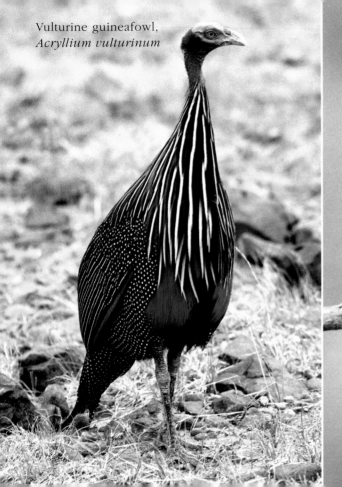

Vulturine guineafowl,
Acryllium vulturinum

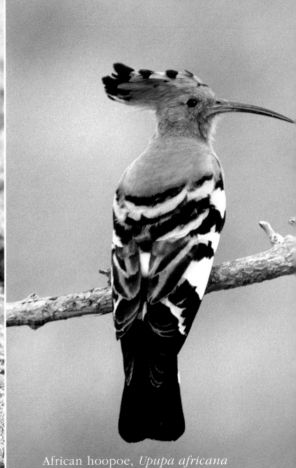

African hoopoe, *Upupa africana*

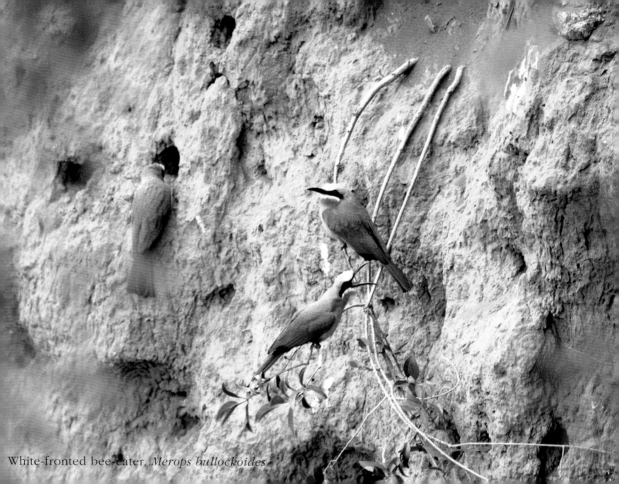

White-fronted bee-eater, *Merops bullockoides*

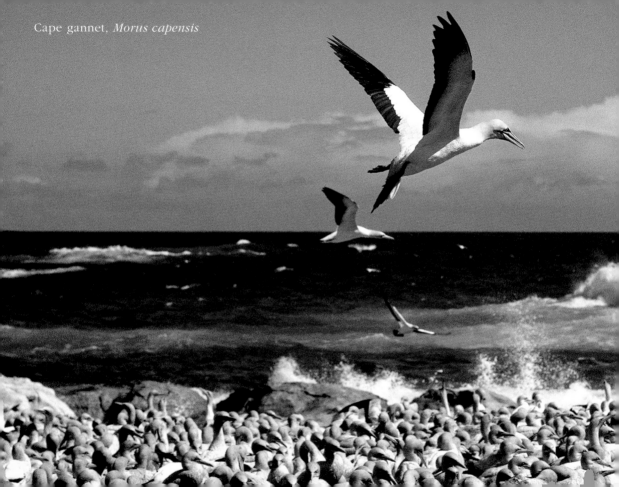

Cape gannet, *Morus capensis*

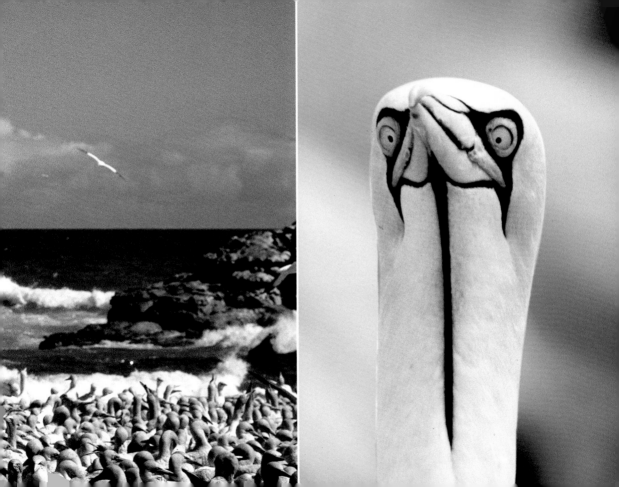

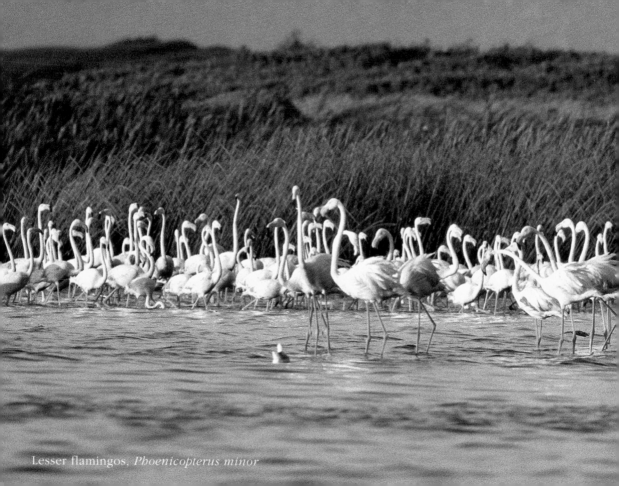

Lesser flamingos, *Phoenicopterus minor*

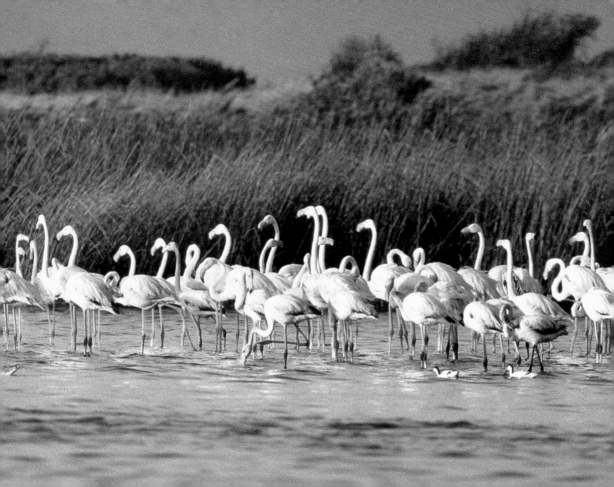

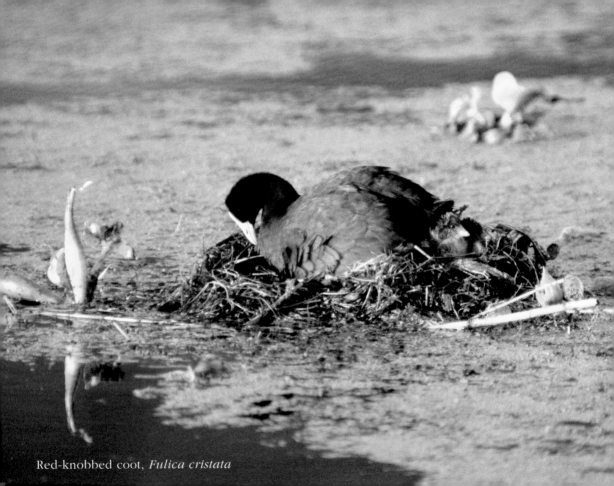

Red-knobbed coot, *Fulica cristata*

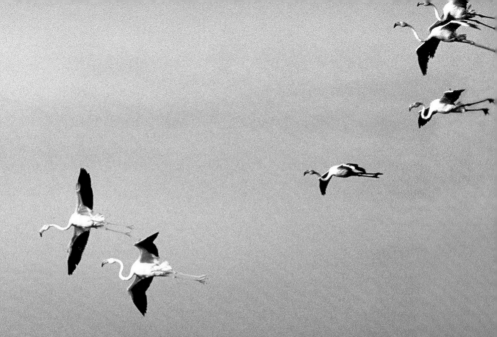

Lesser flamingos, *Phoenicopterus minor*

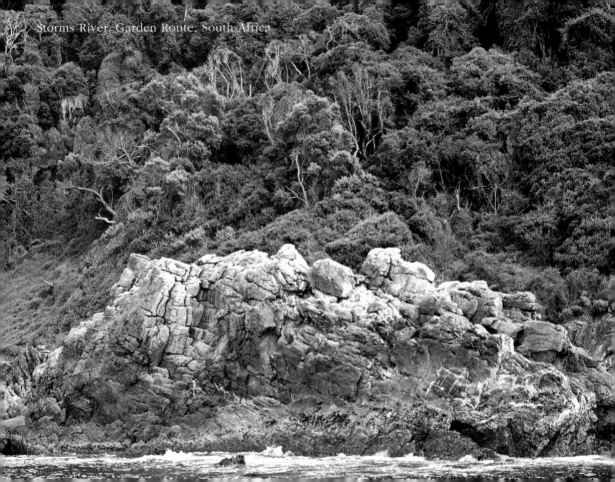
Storms River, Garden Route, South Africa

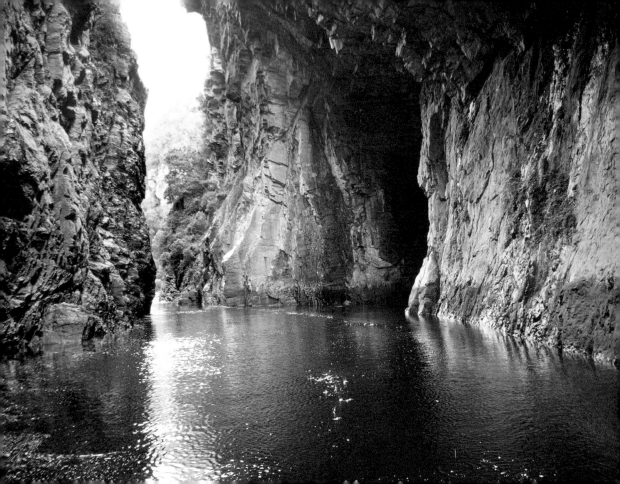

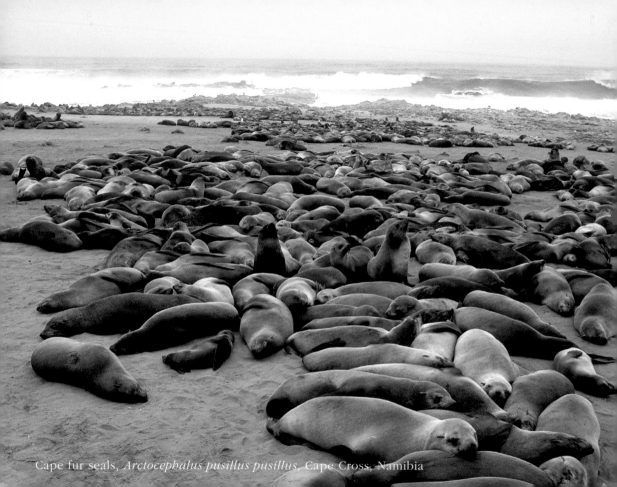

Cape fur seals, *Arctocephalus pusillus pusillus*, Cape Cross, Namibia

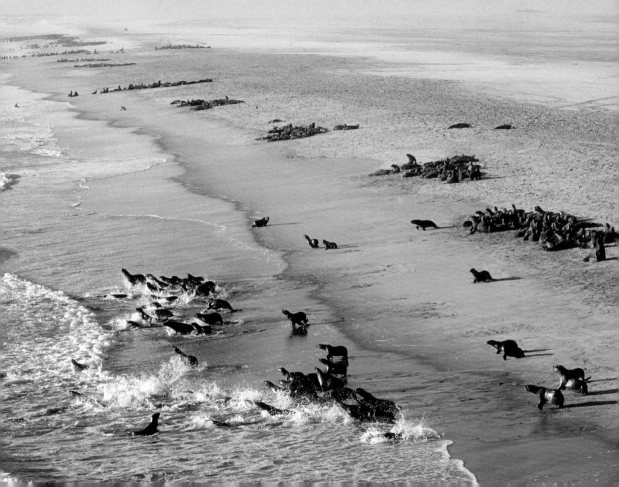

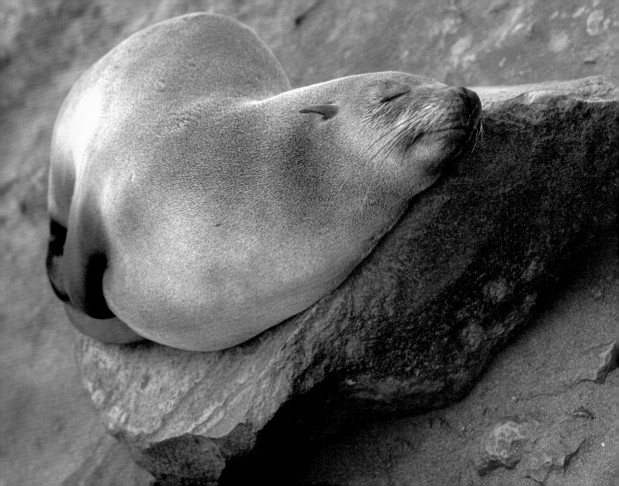

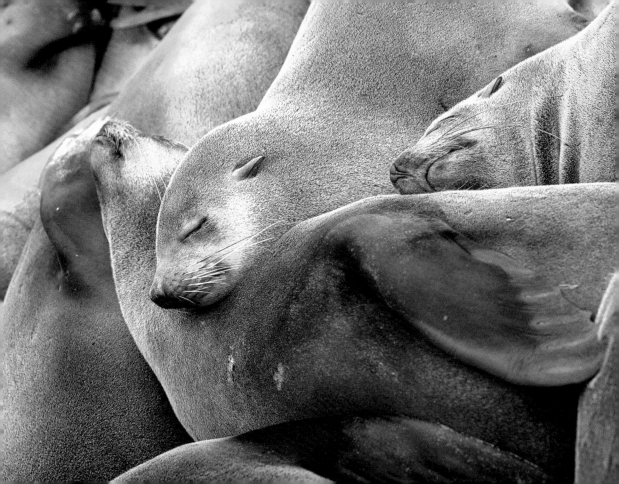

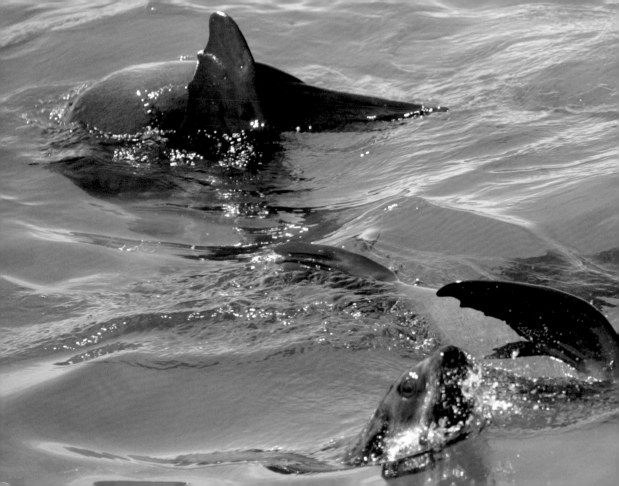

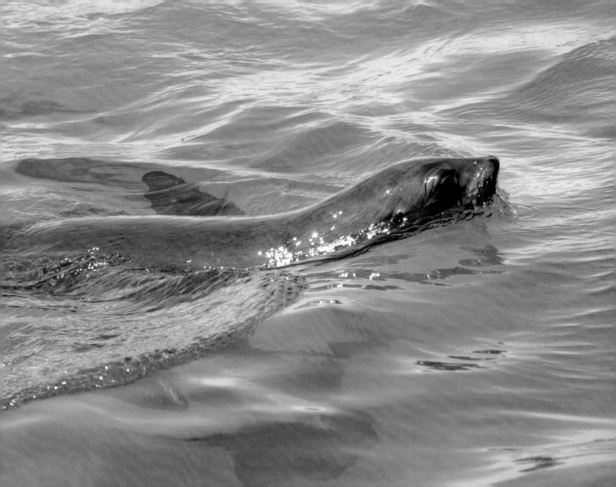

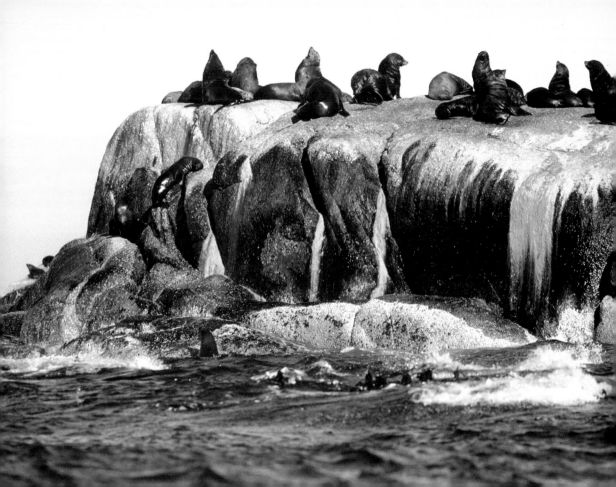

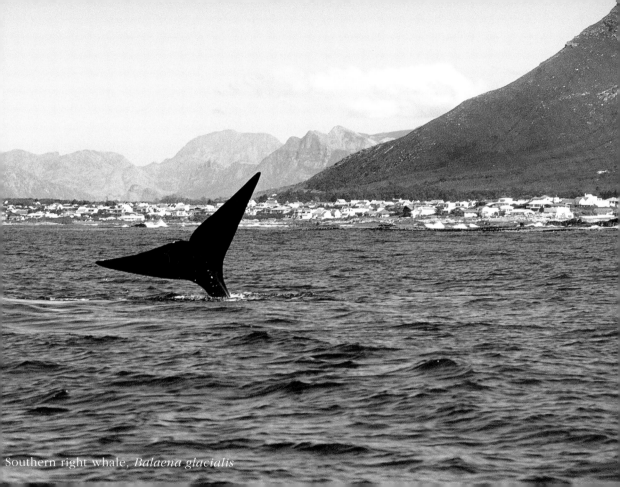

Southern right whale, *Balaena glacialis*

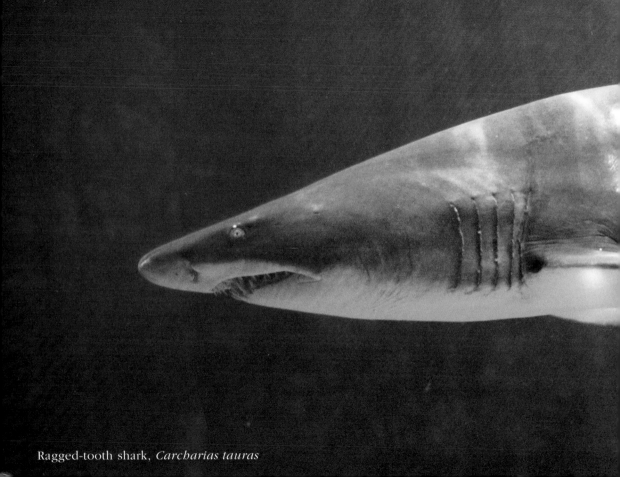
Ragged-tooth shark, *Carcharias tauras*

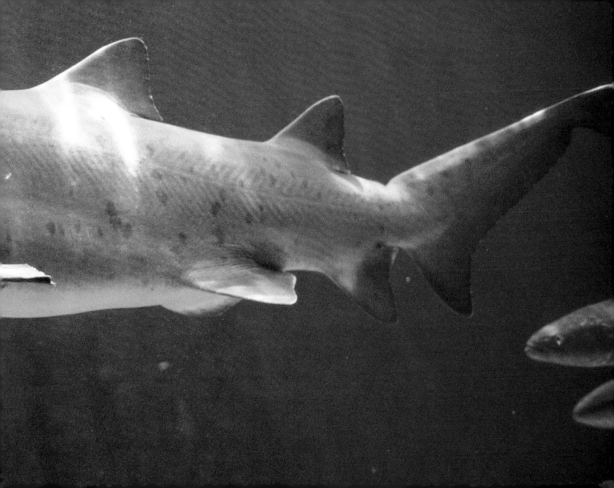

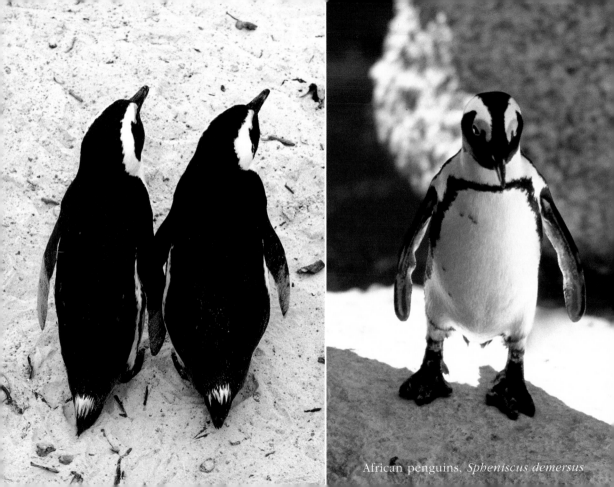

African penguins, *Spheniscus demersus*

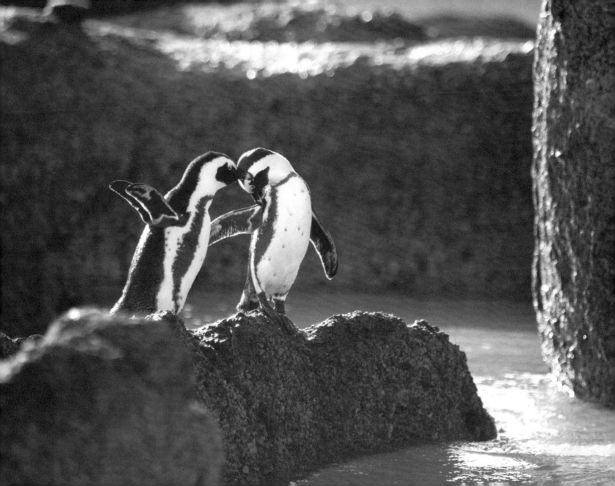

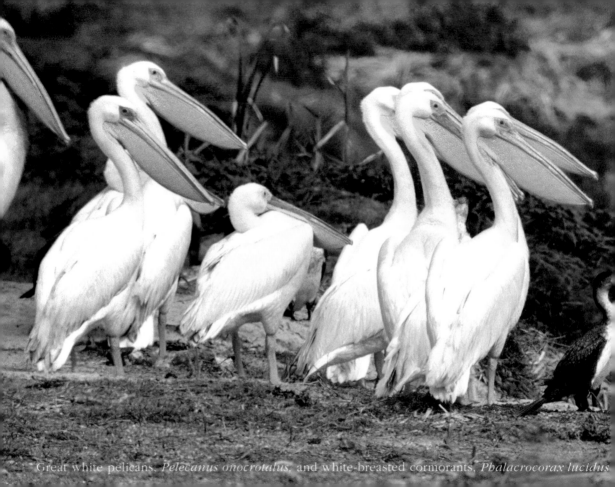

Great white pelicans, *Pelecanus onocrotalus*, and white-breasted cormorants, *Phalacrocorax lucidus*

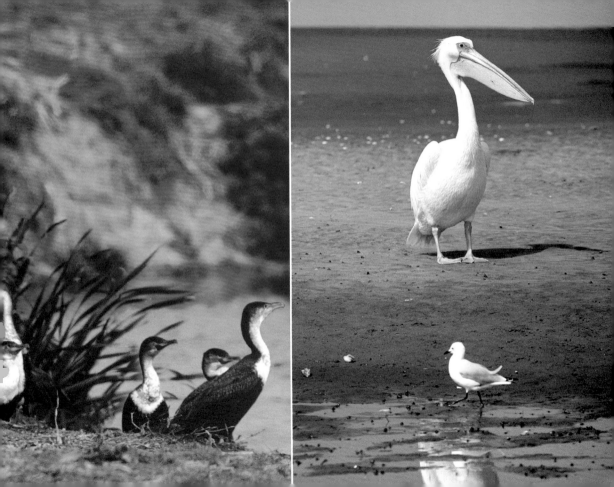

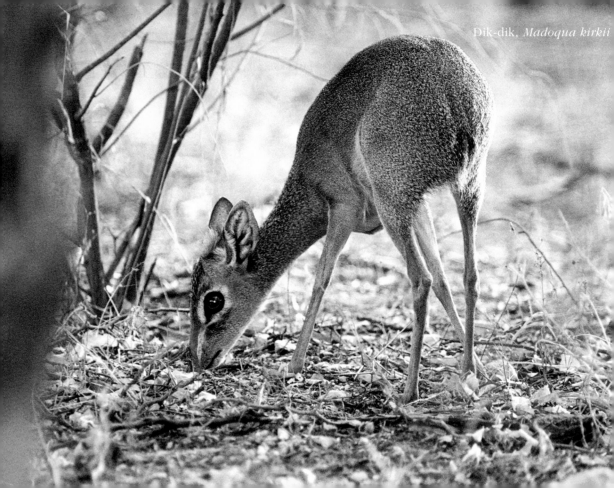

Dik-dik, *Madoqua kirkii*

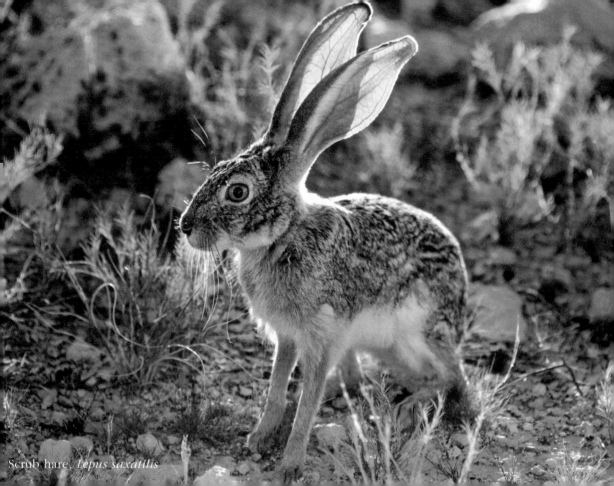
Scrub hare. *Lepus saxatilis*

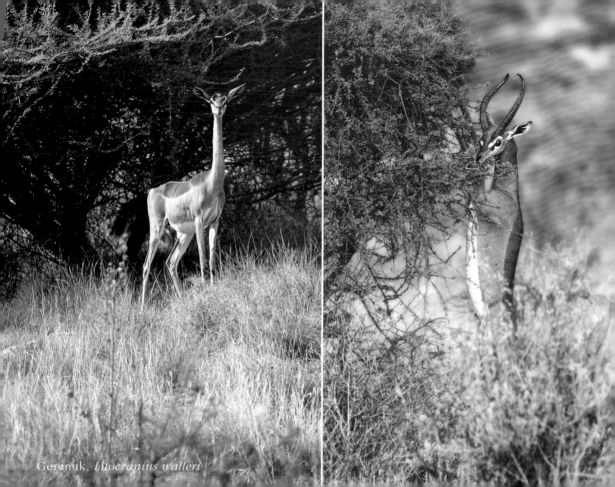

Gerenuk, *Litocranius walleri*

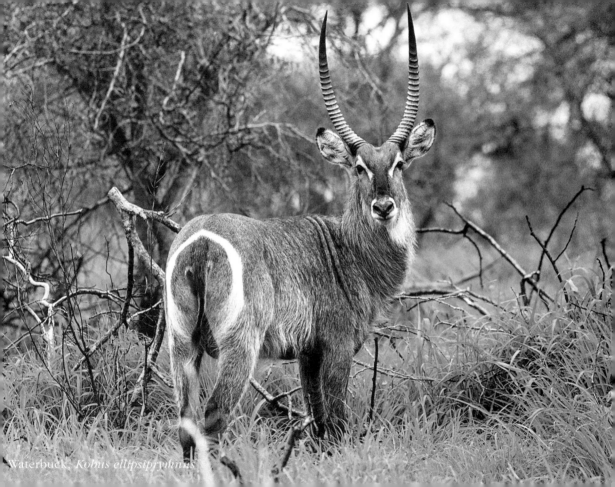
Waterbuck, *Kobus ellipsiprymnus*

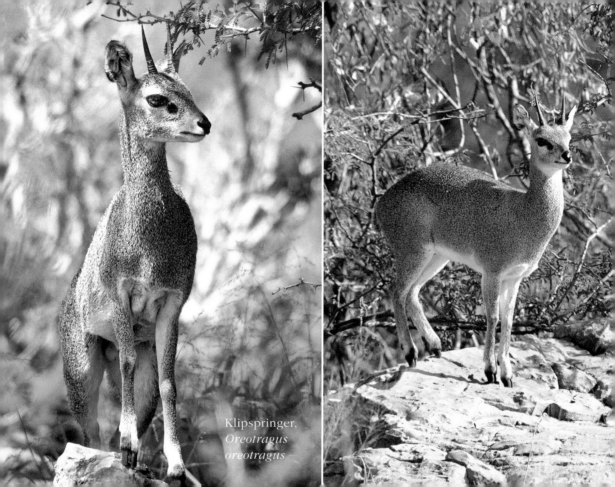

Klipspringer,
*Oreotragus
oreotragus*

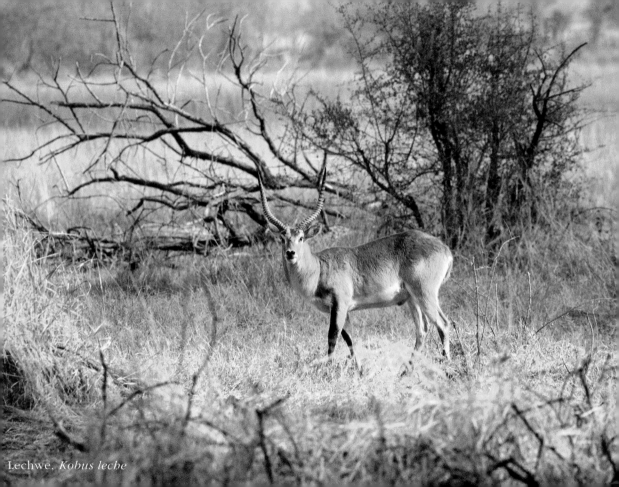

Lechwe, *Kobus leche*

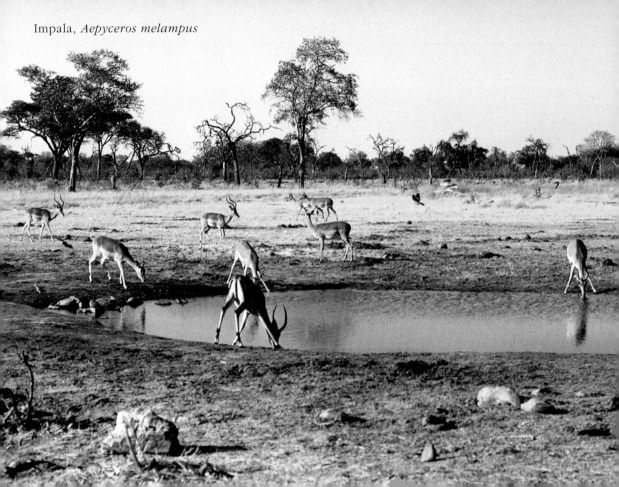

Impala, *Aepyceros melampus*

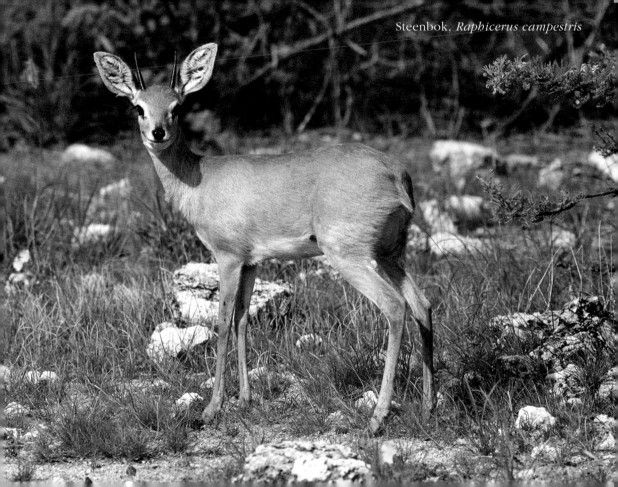

Steenbok, *Raphicerus campestris*

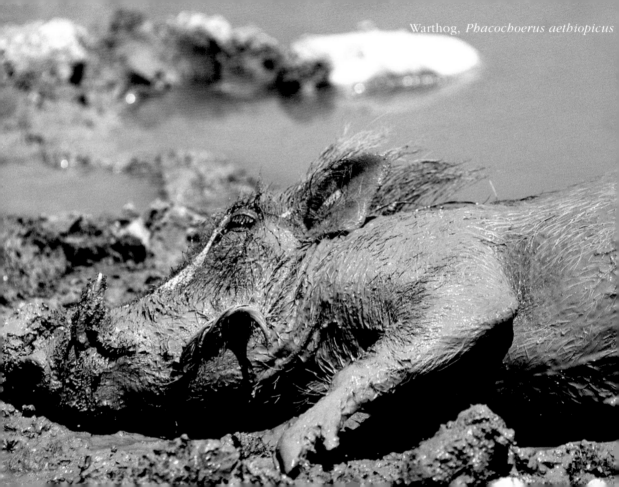

Warthog, *Phacochoerus aethiopicus*

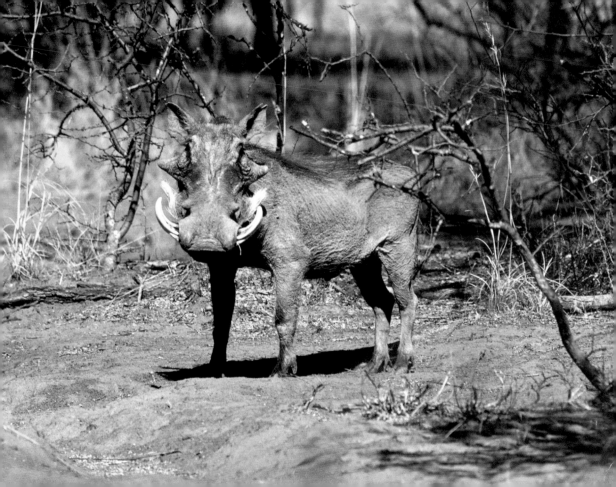

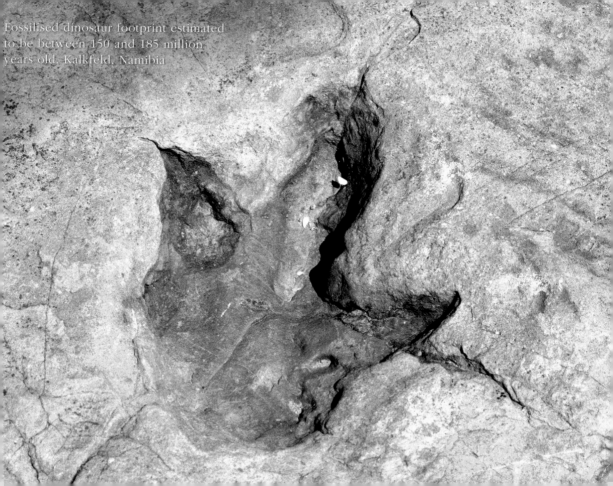

Fossilised dinosaur footprint estimated
to be between 150 and 185 million
years old, Kalkfeld, Namibia

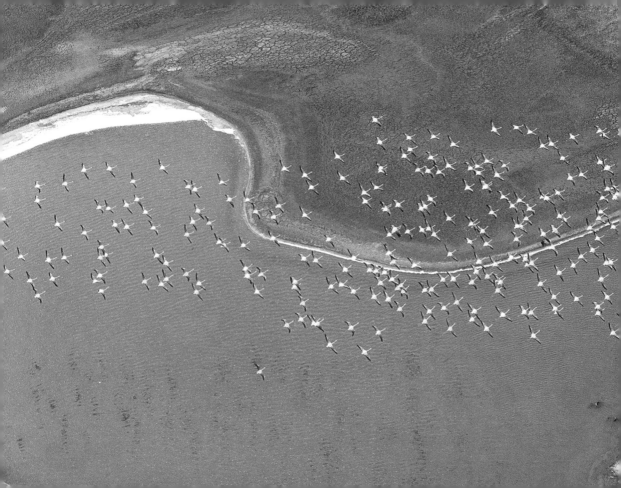